IMAGES
of America
ROMEOVILLE

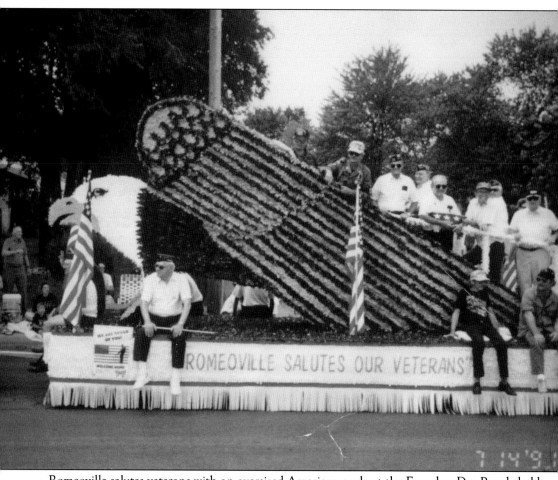

Romeoville salutes veterans with an oversized American eagle at the Founders Day Parade held annually in September. Daniel Sawain is standing second from the left behind the wing, and veteran Lester Belinksi is standing fourth from the left behind the wing. The other veterans are unidentified. (Courtesy of the Romeoville Area Historical Society.)

ON THE COVER: Cub Scouts from Valley View School Pack No. 20 in 1957 had fun learning boating skills. Since Romeoville was not yet recognized as a village, the identification strips seen on the women's uniforms read "Lockport." Cubs, from left to right, are Michael Alexander and David Hassert; Cubs also in the boat but not pictured are Gordon Bavarskis and Nicholas Matos. The den mothers are Mrs. John (Mary) Alexander, left, and Mrs. Hayes (Dorothy) Alexander. (Courtesy of the Romeoville Area Historical Society.)

IMAGES
of America
ROMEOVILLE

Nancy Hackett and the
Romeoville Area Historical Society

ARCADIA
PUBLISHING

Published by Arcadia Publishing
Charleston, South Carolina

Printed in the United States of America

Library of Congress Control Number: 2013934947

For all general information, please contact Arcadia Publishing:
Telephone 843-853-2070
Fax 843-853-0044
E-mail sales@arcadiapublishing.com
For customer service and orders:
Toll-Free 1-888-313-2665

Visit us on the Internet at www.arcadiapublishing.com

We dedicate this book in memory of the pioneers of Romeo and in memory of Mabel Hrpcha, Dorothy Hassert, and Joyce Kinder, founders who have recently passed away.

CONTENTS

ACKNOWLEDGMENTS

Mark Frost and Joyce Kinder searched for Romeoville history in 1980, leading to the formation of the historical society. Founding members, including longtime residents who donated their time and cartons of memorabilia to begin the museum, have kept our history alive. Gladys Hakey, Dorothy and Howard Hassert, Mabel Hrpcha, Jay and Joyce Knepp, Shea and Thomas Martin, Alice Spangler, Hazel Williams, and others worked tirelessly to organize the collection and share it with the community. Dorothy Hassert's book *From One-Room Schools to District 365U, DuPage Township, Will County, Illinois* (Valley View School District) and Mabel Hrpcha's *Romeoville* provided invaluable information.

Mary and Kelby Briddick and Shirlee Pergler wrote the chapters on the canal and farming. James and Mary Grant and Joyce Kinder provided the "Homes Built in a Day" chapter. Arthur "Art" Arellano, Rita Bazzell, Shirlee Pergler, Melba Tolbert, and Annette and Kyle Eichorst spent hours searching the files. We also thank the residents and businesses who shared memories, loaned their photographs to fill the gaps in our archives, and provided technical help. We thank the following: Brian Clancy, Jerry Capps, James and Mary Grant, Helen Groh, Joyce Kinder, Rita Raisor, Albert Stadelmeier, the Haacks, Lea Moore, Carl "Chief" Churulo, Jeanne Durrer, Thomas Rednour, Melba Tolbert, Ronald Otto, Earl Hassert, Rev. James Fisher, Lorna Gunty, and others. Joe Wojcik provided modern pictures as noted (JW). The Romeoville Area Historical Society thanks the village of Romeoville for its support in this endeavor.

We carefully researched the information provided in written and oral form to ensure accuracy. The presence or absence of families is completely due to the records and photographs available to us. Realizing that memories and oral history are not always correct, we apologize for inconsistencies. Unless otherwise noted, all images appear courtesy of the Romeoville Area Historical Society (RAHS).

INTRODUCTION

Romeoville has an unusual history with a half dozen distinct lives from its early Indian trader days to a vibrant modern community. Families that settled during the early 1800s cooperated and established longtime friendships, depending on each other for basic necessities. Hampton Park brought village life with formal government and larger schools. Life settled down after the frenzy of building Hampton Park until the 1990s, when a new housing and business boom occurred.

Easterners arriving in 1830 settled near the junction of two branches of the DuPaz (DuPage) River, known as Fountaindale. Cook County, organized in 1831, encompassed seven current counties including Will, but a vote to secede from Cook County and create Will County passed by one vote. The first school, Old Hickory, was built in 1832 at the DuPage River and Barkdol Road. When the Illinois and Michigan (I&M) Canal construction began in 1836, Lockport, Lemont, Romeo, and Juliet (now Joliet) were built to house canal workers. Unlike other canal towns, Romeo did not grow. DuPage Township was organized, and its boundary lines adopted at Old Hickory School in 1850. The Gulf Mobil & Ohio Railroad (Chicago & Alton) began operation through Romeo in competition with the canal in 1854. The Chicago & St. Louis Railroad built tracks through Romeo in 1884, acquired by the Santa Fe Railroad in 1886. The Romeo depot was used for more than half a century. Romeo quarries provided stone for the canals, the capitol in Springfield, and local public buildings, and they are still running today. When Bruce's Quarry was filled with water, it became Romeo Beach, a popular resort, and ice was cut there in the winter. The Oklahoma Oil Company, Union Oil, built the first refinery in 1923.

At Miller's Barbershop in January 1895, the people of Romeo voted to incorporate the community into a village. Romeo's first telephone station, installed on November 30, 1900, provided eight-party service. In 1901, a streetcar line began running from Chicago to Joliet, through Romeo along New Avenue.

A fire in Romeoville destroyed seven frame buildings on April 11, 1918. The entire town was threatened due to strong winds and the lack of a fire department. Neighbors obtained water from wells and the I&M Canal to strike out the fires. Fire destroyed the Connell and Anthony Startz homes on February 23, 1934, but the Lockport Fire Department saved the Heeg home with quarry water after chopping through thick ice. When a double-wide trailer ignited and exploded in 1958, two of the eight children inside survived. Refinery fires and explosions have killed staff and firemen and rocked neighboring towns.

Restaurants and taverns such as Sarsfield's, Murphy's Romeoville Café, Chick's Tavern, Startz's tavern, and the Roadside Inn abounded. Gleaners Hall, built in 1922 on Route 66A, was used for social activities for more than four decades. The restaurant where John "Jack" Peabody served food to race fans was purchased by the Hasterts and opened as the White Fence Farm Restaurant in 1954.

The local legend says that during Prohibition, Alfonso "Al" Capone brought his liquor on boats to Romeoville, where it was transferred to cars and driven into Chicago at night. Car trouble

in Romeoville saved several of his men from the St. Valentine's Day Massacre. The Civilian Conservation Corps, created during the Depression, built park facilities along the I&M Canal in Romeoville.

Neal Murphy began 40 years of service as mayor of Romeoville in 1929. Reelected nine consecutive times, he took the village from a $400 debt and a population of 180 through the building of Hampton Park, which added 3,000 residents by his retirement. In July 1958, the village board approved building permits for Hampton Park where veterans could buy homes for $10 down. Sales soared. The first residents arrived in November to cope with gravel roads, backyard propane tanks and trash incinerators, and a public telephone booth on a street corner. Included in the development was a village hall but no downtown. The adversities led to quickly developed friendships as residents arranged shopping trips and shared the public telephone. Since fathers drove the family car to work, children could play everywhere without worrying about traffic. At the end of construction, growth stopped again with about 15,000 people. When a large debt was accrued in the 1980s–1990s, village officials began courting housing developments and industrial growth simultaneously, which provided staff for the new businesses and jobs for residents. The growth spurt brought in needed business tax revenue to cancel the debt and improve the infrastructure. Housing developments in the west and southwest of the village tripled the population.

Early families are well represented in current Romeoville. The Startz, Eichelberger, Heeg, Keig, Fracaro, Ward, Boehme, Pounovich, Kirman, Konicek, and Murphy descendants continue their close ties and participation in village activities. Later arrivals, such as the Hasserts, Clancys, Hasterts, and McCartans, became active in township and village government during the 1950s and 1960s.

The Lewis Holy Name Aeronautical School grew into Lewis University. Valley View School replaced one-room schools in 1954. Park View School opened in 1962, and Valley View School District was born. Lockport West High School opened in 1963 for students in Romeoville, Bolingbrook, and Crest Hill and was incorporated into Valley View in 1972. In 1970, the school district created the 45/15 year-round school, duplicated around the country. When growth slowed, the district returned to a standard school year in 1980. Joliet Junior College opened its northern campus in Romeoville in 1993. In 2009, Rasmussen College added a campus west of the village.

The Romeoville Jaycees conducted a survey in the 1960s to determine the needs of residents, expecting a swimming pool to be the first choice. However, the overwhelming desire was for a library, so they began to create a library district for DuPage Township, encompassing neighboring Bolingbrook, a smaller community. The Fountaindale Public Library District, named for the junction of the DuPage River branches, began in 1970 in Park View School. Construction was completed and the identical buildings opened in 1975. In 2010, the library district ceded the Romeoville building to the Des Plaines Valley Public Library District, renamed the White Oak Library District in 2011.

The Will County Forest Preserve District opened the Isle a la Cache nature preserve in 1983. Neal Murphy's Romeoville Café became a museum, with the café's bar as its service counter. The Isle a la Cache became part of the National Park System's Illinois and Michigan Canal Corridor a year later.

The historic 97-year-old 135th Street Bridge was suddenly closed in 1990, separating residents and businesses east of the canal from the rest of the village. Discovery of a rare emerald dragonfly habitat halted demolition. The unique style of the bridge delayed work further while photographs documented it and its move to a nature trail. A new bridge finally opened eight years later.

The Carillon senior community opened west of Romeoville in 1988. Increased use of Weber Road led to a new interchange at Interstate 55 in 1989 and to development of the Weber Road corridor until businesses filled Weber Road from Bolingbrook to Crest Hill. By 2010, the boundary of the village had pushed west and south with new development that surpassed the growth in the 1960s.

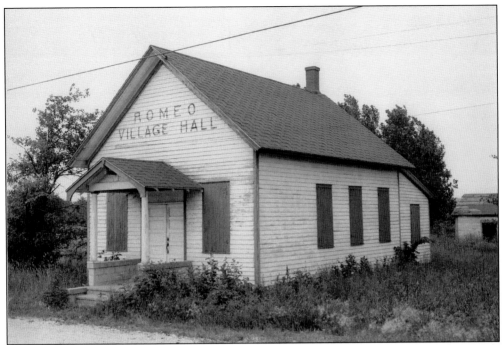

The first Romeo Village Hall was built east of the I&M Canal in 1895. According to the records accessed, the village was incorporated in 1895 or 1901. When the Alexander Construction Company built a new village hall for Hampton Park in 1960, the building looked like this. It began to be used by Scout troops, a youth club, and other agencies that needed meeting space.

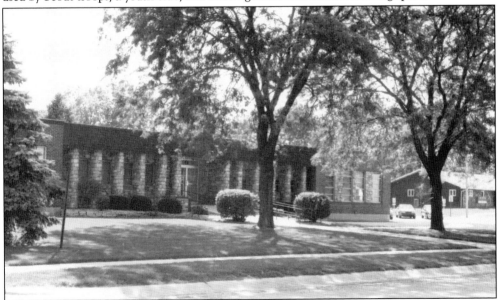

The village hall built for Hampton Park by Anderson Construction in 1959–1960 was a large modern facility that replaced the original 60-year-old Romeo Village Hall. The large garage doors on the right housed the volunteer fire department. Each department had an office. The boardroom had an impressive table and space for fewer than 40 observers. In the 1970s, the police and fire departments moved into their own buildings across the street.

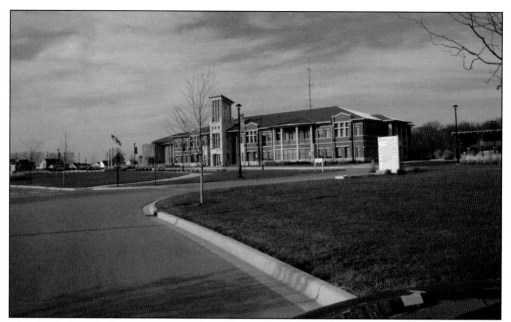

The third village hall complex was dedicated in 2010. The village offices are in the right-hand side of the building, with the police station on the left. The spacious building holds offices for each department, conference rooms, a boardroom that can accommodate an audience of numerous residents, and the studio for Romeoville Public Television, RPTV. (JW.)

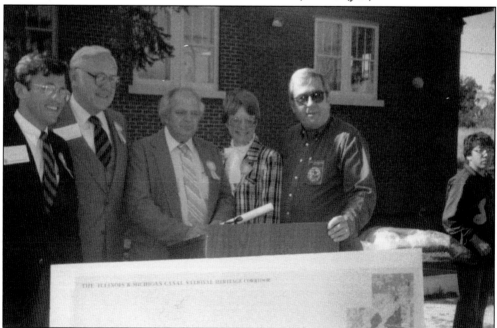

Pres. Ronald Reagan signed the bill to establish the Illinois and Michigan (I&M) Canal Corridor in 1984. It was presented at a ceremony in Romeoville. From left to right are Will County Board member Gerald Adelmann, Rep. George O. Brien, Mayor Howard Trippett, DuPage Township commissioner Judith "Judy" Bredeweg, and an unidentified representative of the forest preserve district. In front of the podium is a diagram of the corridor.

10

Joseph Wagner, who was the village clerk in 1901 and 1912–1913, designed the Romeoville village seal. He incorporated the silhouette of the landmark Lockport/DuPage Grain Elevator in his design to depict the rural lifestyle of the area.

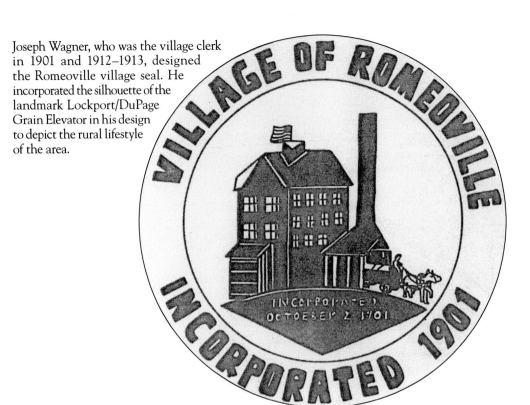

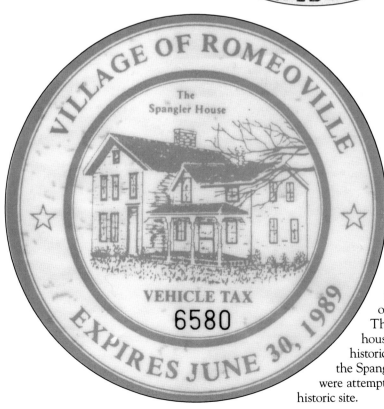

The Romeoville automobile permit sticker in 1989 commemorated the historic Spangler house, the farmhouse of Alice Phelps Spangler who had been the treasurer for the DuPage Township one-room schools. This recognition of the house occurred when the historical society and the Save the Spangler House Committee were attempting to preserve it as a historic site.

Banners fly from poles around the drive of the village hall, built in 2010. The striking white-on-maroon colors and the village's slogan "Village of Romeoville Where Community Matters" are on each of the flags, paired with banners of local historic sites and businesses. (JW.)

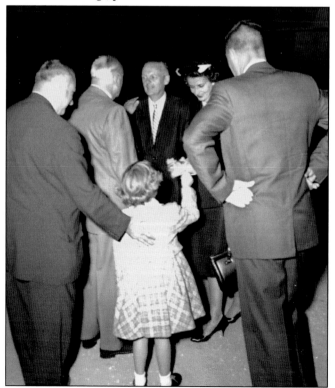

Dignitaries facing the camera at the dedication of Hampton Park around 1960 are Mayor Neal Murphy, Gov. William G. Stratton, and Shirley Stratton. Young Deborah "Debbie" Hassert presents a corsage to Shirley Stratton. Debbie's father Howard may be on the left with his back to the camera. The second man facing away is unidentified.

One

BEFORE ROMEOVILLE BEGAN

The early residents were the Potawatomi Indians and other tribes who traveled along the river. They brought their furs to trade with the French voyageurs. The area was known as Fountaindale for the freshwater springs.

Louis Joliet and Fr. Jacques Marquette explored the region in 1673. About 150 years later, Congress decided to build the I&M Canal along the Des Plaines River. The Indians were moved northwest across the Indian boundary line. Plans for the canal included towns and houses for the workers and their families. Romeo and Juliet were born as twin cities east of the canal. In 1827, lots bordering the canal were sold to the public. The Romeo plat was recorded on September 14, 1835, at the Cook County Courthouse. After Juliet was renamed "Joliet" to honor Louis Joliet, Romeo became Romeoville either in 1845 or at incorporation in 1895. On July 4, 1836, ground for the canal was broken in Bridgeport, Illinois. The canal joined the Illinois River to Lake Michigan, connecting the Great Lakes, through the Mississippi River, to the Gulf of Mexico. The canal had to be carved into the raw frontier. During construction, financial, engineering, and physical difficulties, such as cholera and malaria, were encountered. The deepest descent was between Lockport and Joliet. Immigrant workers, who were given whiskey and a dollar for their 14–15 hour days, six days a week, mainly did the construction work. Housing was in hastily built unsanitary camps. The overseers provoked some of the riots and attempts of murder that ensued. The canal was dug along the Des Plaines River, beginning at Lake Michigan. The summit level of the I&M was from Bridgeport to Lockport, the middle from Lockport to Seneca, and the western section from Seneca to LaSalle. When completed, it stretched 100 miles with 15 locks and cost $9.5 million. The first small boat to be used on the canal when it opened in 1848 was the *General Fry* or *Thornton*, which was built in Lockport in 1847. Mules pulled boats until 1870. (For more detailed information about the I&M Canal, see John Lamb's books.)

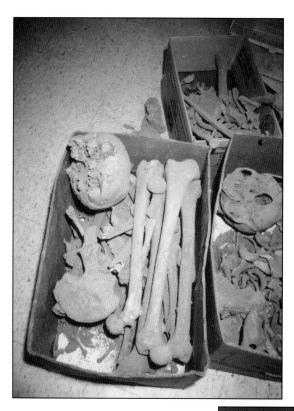

Barry Bankroff discovered an Indian burial pit in 1984 while digging to install a septic tank on High Road in old Romeo on the east side of the river. The remains of a man, woman, seven-year-old, and an infant were dated to the Woodland Period between 300 BC and 1200 AD. (Bear Photo by Barry Bankroff.)

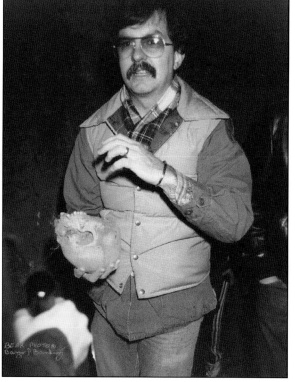

An anthropological consultant for Will County, Dr. Robert Pickering of the Field Museum in Chicago holds a skull found in the burial pit. The bones were taken to the Field Museum for further study before delivery to a depository in one of the state universities. (Bear Photo by Barry Bankroff.)

Reenactors at the Isle a la Cache Island Rendezvous portray people of the fur-trade era in the 18th century. Although Isle a la Cache was used more as a landmark and rest stop for traders, each year the fur trade is celebrated at Isle a la Cache. In this image, Jacqueline "Jackie" Parker demonstrates the procedure for making straw brooms. She has utilitarian and more elaborate styles to sell.

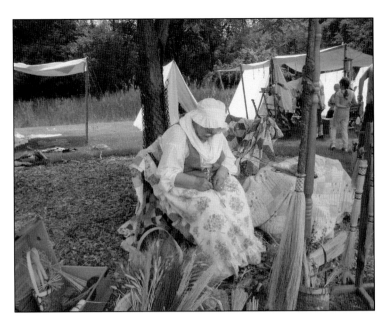

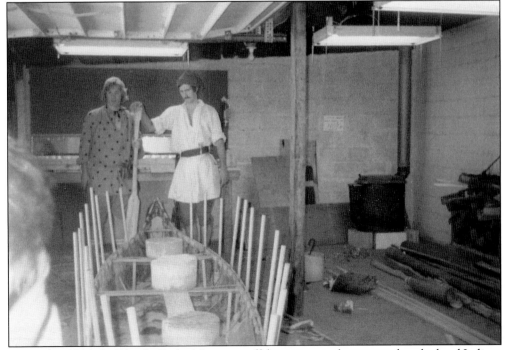

Pictured in 1986, the Isle a la Cache Museum staff demonstrates the process that the local Indians used for building a birch-bark canoe. After soaking the birch bark, it was curved into shape. The sticks helped maintain the shape of the canoe until the wood frame dried. The canoes were the only method of transportation, other than walking, for Indians in this area.

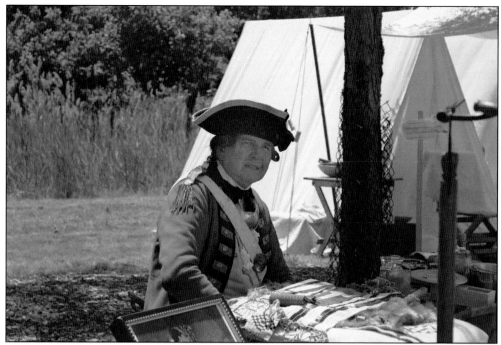

Bernie Kazwick portrays a British officer at Island Rendezvous. Using maps and replica items, he tells the story of the British army during the 18th century. Although the British army neither fought nor was stationed here, the area served as a transportation corridor between Detroit and western Illinois. (JW.)

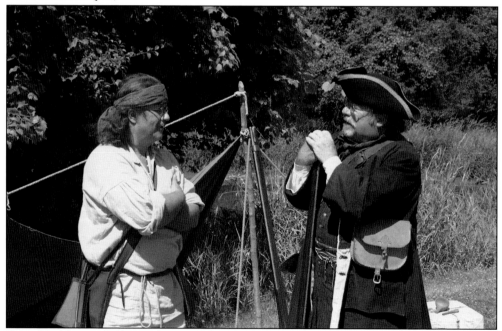

Harry Klinkhamer (left), coordinator of the Isle a la Cache Forest Preserve, talks with Daniel Vogt, one of the traders, about his goods. The tents at the annual Island Rendezvous are arranged as they might have been when the voyageurs traded with the local Native American tribes. (JW.)

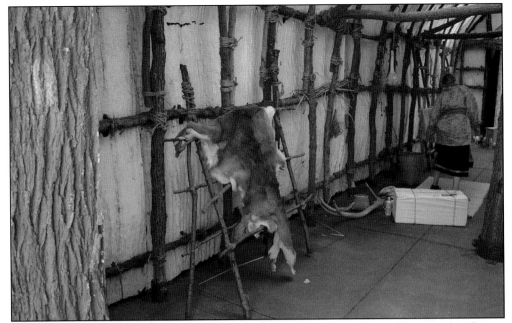

Native Americans of the area had primarily two types of dwellings. Pictured here is a longhouse. This would be the summer home, housing several families at once. In the warmer months, tribes stayed closer together as they farmed communally. This reproduction was built in 2003 at the Isle a la Cache Museum to be used for educational programming. A deer pelt hangs from the wall. (JW.)

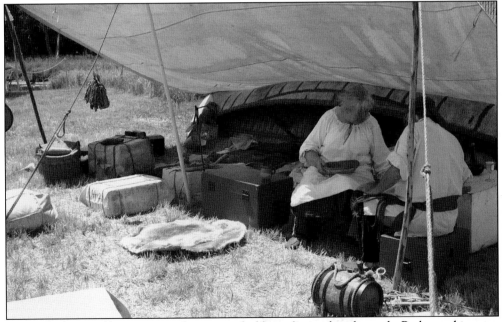

Woven baskets and boxes wrapped in canvas hold supplies and trade goods. Basket-making was an important skill of the Native American women, who taught the settlers how to make and use them around their homes. Hides or canvas coverings protected supplies when traveling in canoes. (JW.)

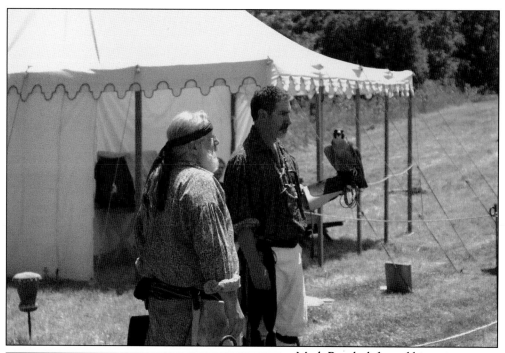

Mark Booth, left, and his assistant exhibit their falcon. Although falconry is an old sport, it probably was not practiced by Native Americans or early settlers, who were too busy with practical matters such as hunting and planting to survive. (JW.)

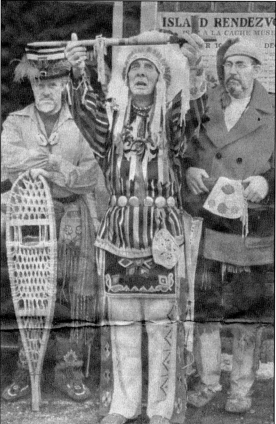

Cherokee Indian Tom Greenwood from Willow Springs (center) holds a peace pipe at the opening of the Isle a la Cache Museum in Romeoville on December 12, 1983. Voyageur Maurice Parkin of Elmhurst is on the left, and Ralph Frese of Chicago is on the right. (*Herald-News* photograph by John Patsch.)

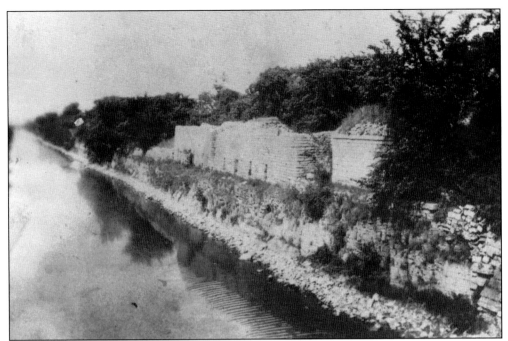

Col. George Martin operated the granary, which collected and distributed grain from the boats, on the canal at Martin's Landing near Romeo Road. The remains of the granary were photographed around 1940. Most of the walls along the canal were destroyed when the high electric wires were installed. Colonel Martin also operated the Gaylord Building, also known as the Public Landing, which is a landmark in Lockport.

Ann and Paul Jurca bought the old Fitzgerald home on Bluff Road in the 1950s. Paul continues to live there in the 2010s. At the age of 93, he still raises chickens and is active on the farm. Paul was a member of the Lions Club. He and Peter King started a baseball team of boys from the farms, the King's Barbers, named for their sponsor, King's Barbershop.

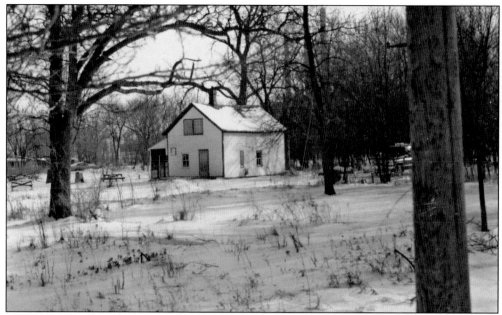

During the building of the Chicago Sanitary and Ship Canal in 1895, this house was erected on the south side of Romeo Road, west of the east fork of the Des Plaines River. Between the 1920s and 1950s, the Altman, Felber, and Nichols families occupied it. The Will County Forest Preserve bought it in the 1990s.

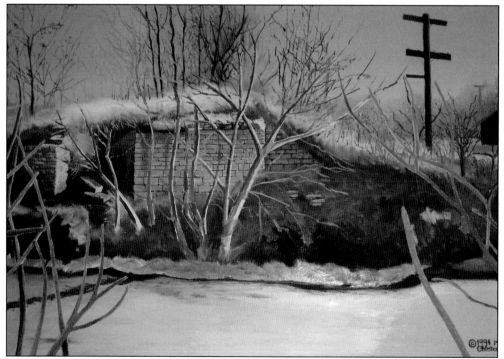

In the 1990s, local artist Michael Chlebanowski painted a series of views of the I&M Canal from photographs he took in the late 1980s. A local division of the Civilian Conservation Corps during the 1930s probably built the footbridge over the canal. (RAHS.)

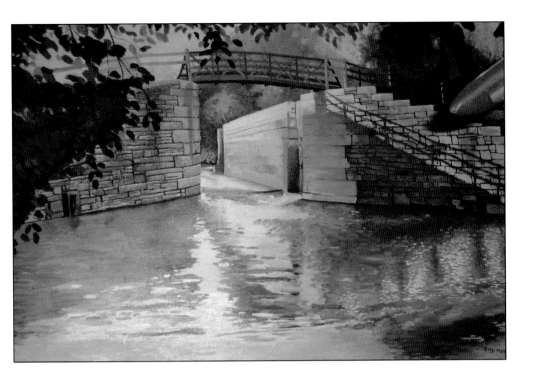

Two more of Michael Chlebanowski's series of views of the I&M Canal appear here. The water in the first picture of the lock and bridge shines even in black and white. In the view below, the lock tender and his assistant work the long levers to open a lock. After the boat enters the enclosure, they will have to close the lock and open the second lock seen above them. The paintings, purchased by the Friends of the Library, hung in the Romeoville branch of the Fountaindale Library until 2010. They can now be seen at the historical society museum. (Both, RAHS.)

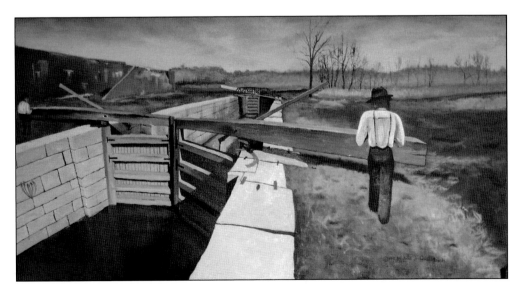

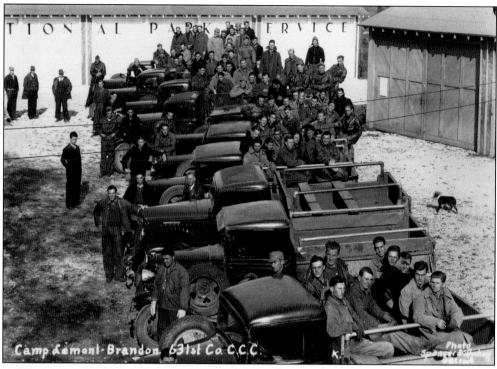

Camp Lemont-Brandon 631st Co. C.C.C.

During the Depression, the Civilian Conservation Corps worked to improve the I&M Canal. The photograph shows the men based at Camp Lemont-Brandon near Big Run Golf Course on Romeo Road. They built shelters and bridges, repaired the stone walls on the canal, removed debris, trimmed trees, and planted bushes. One shelter was built on the canal path south of Romeo Road. Martin Fracaro from Romeoville worked with the Civilian Conservation Corps in this area and kept a photographic record of his life. In the picture at left, his sister Mabel Fracaro Hrpcha stands near the fireplace that remained in 2004. (Both, courtesy of Mabel Hrpcha.)

Two

ISLAND NEIGHBORS

Isle a la Cache, an 80-acre island located in the Des Plaines River at Romeo Road, was a voyageur camp. It is said that the place was named Isle a la Cache for a Frenchman who hid his supplies there to evade the Indians' toll. Known locally as the island, Isle a la Cache had as many as 18 homes, a church, hotel, and several taverns. During construction of the canals, a temporary post office was established. Catholics and Protestants, who held separate services, built the church near the west fork of the river. Some homes were constructed to rent to summer visitors and hunters. Permanent settlers on the island later became part of Romeo. Joseph Startz owned the wooden Island Hotel. After a devastating fire in 1918, Frederick Boehme Sr. purchased the property and erected a two-story cement block hotel and saloon, known as the Riverside Inn. A few families continue to live there, although most of the island is the property of the Will County Forest Preserve.

Digging created Romeo Beach in Bruce's Quarry. Situated east of the canal and river and south of Romeo Road, it was a popular retreat from summer heat in the city. Joseph Startz would meet the train with a surrey to transport visitors to the beach, hoping that they would stay at his hotel. In winter, the Bruce family cut ice there.

Neal Murphy built Murphy's Café, a popular restaurant and tavern, on the island. Ruth Murphy was the cook, and Raymond "Betsy" Cora helped Neal tend bar. Murphy was mayor for 40 years, from 1929 into the birth of Hampton Park and the reincarnation of the village. When the Will County Forest Preserve bought Isle a la Cache and opened the Isle a la Cache Museum in December 1983, the café became the visitors' center, and the bar was changed to the reception desk. As part of the National Parks Canal Corridor, it attracts visitors from around the country. In June, the Island Rendezvous celebrates the Indian and voyageur heritage of this area.

A c. 1940 aerial view of Isle a la Cache shows Murphy's Café, the rental cottages, and the houses of the few farming families living there. According to reports, there were 18 homes, a church, and several restaurants and taverns. The Army Corps of Engineers dredged the river at this time to prevent flooding. Some families continue to live there, although their homes are now partially under the bridge built in the 1990s.

John J. Keig and other Catholics and Protestants worked together to build the Island Church, paid for by subscriptions and located north of Romeo Road on the west bank of the river. Both denominations held services and Sunday school there. It is believed that the original reason for the church was for the laborers on the Chicago Sanitary and Ship Canal. (Painted by Mabel Hrpcha.)

24

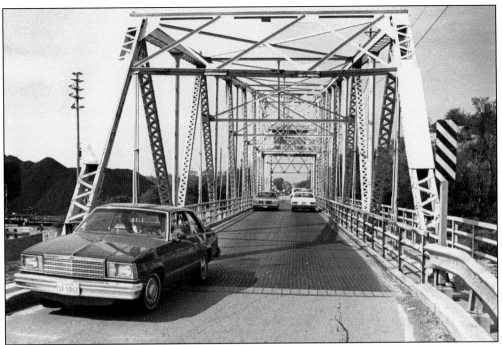

A narrow bridge was built across the canal at Romeo Road around 1898. It swiveled 90 degrees whereas other bridges along the canal rose in the center so ships could pass. The bridge keeper's raised shack helped ensure that cars were off the bridge when he turned it. Strict rules imposed to prevent damage limited the number of cattle and the speed of vehicles. The sharp curve at each end of the bridge may have served horse and wagon but was difficult for cars. The bridge closed in 1990 with no warning, cutting off old Romeo from the rest of the village. Protecting the environment of a rare emerald dragonfly and preserving the historic old bridge caused an eight-year delay in replacement. (RAHS.)

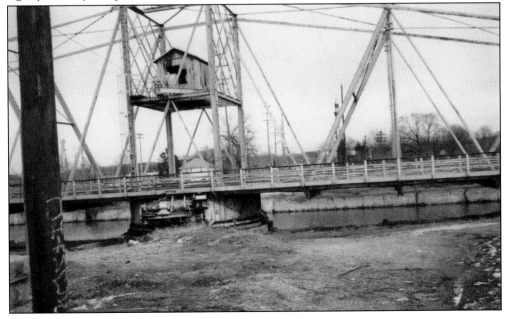

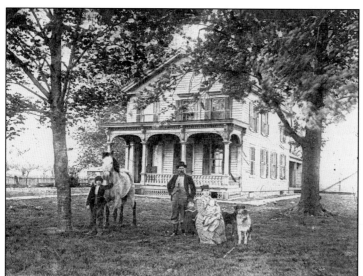

The Williams family poses with its historic c. 1882 house east of the river, between the future Route 53 and Mikan subdivision. From left to right are Thomas with his horse, James, Martha, and baby Kate. It is unknown whether baby Kate is the little girl between her parents or the baby on Martha's lap.

The Sigvald "Sig" Thoresen family converted into a living room the bedroom in the Steven Williams's home where Abraham Lincoln reportedly slept for a week in 1850. Steven Williams, his grandson James Williams, and the Thoresen families made no structural changes to the house in 125 years. The Thoresens sold the property to Alexander Construction Company—this was the beginning of Hampton Park.

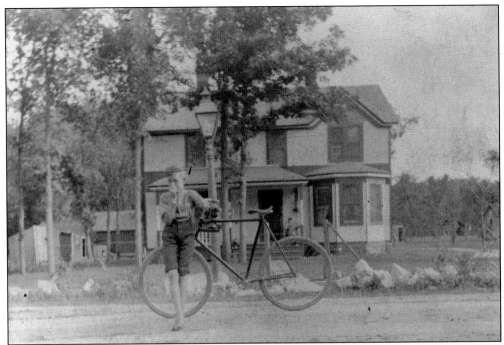

Marshall Keig rides his early bicycle in front of his home on the island. This information is from a description on the back of the picture, which states it is probably Marshall and probably the second Keig home on the island. Legend says that this home was originally erected for the use of officers during the building of the canal.

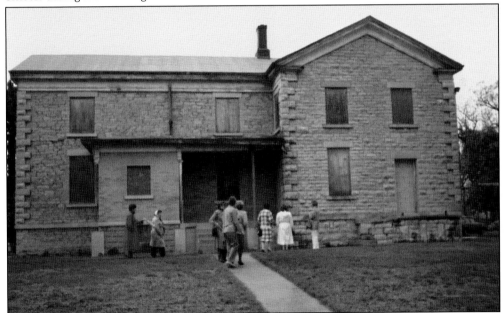

The limestone Greek Revival–style Fitzpatrick house was constructed by Irish immigrant Patrick Fitzpatrick in 1848 along a stagecoach route. According to legend, with hidden stairways and rooms, it was a station on the Underground Railroad. It is currently the office for the Illinois and Michigan Canal Corridor. The picture was taken around 1985 when it was open for visitors.

Peter Startz operated a hunting lodge, called the Red Wing Camping Club, on the first levee of the Des Plaines River. It was a popular place for local outings. Peter Startz can be seen in the center drinking from the pail. The others are unidentified.

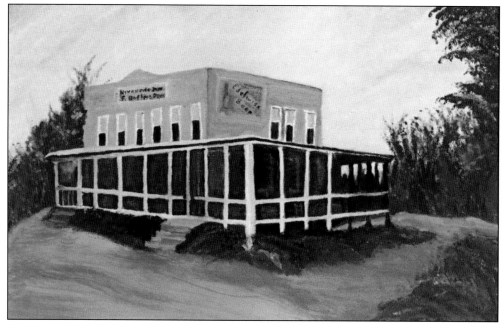

The Riverside Inn was built on the island around 1910 with hand-poured concrete blocks. It became one of the notable nightspots in the area. Proprietor Fred Boehme Sr. was mayor of Romeo from 1921 to 1929. The extended porch appears to be a perfect place for a drink on a hot summer afternoon. (Painted by Mabel Hrpcha.)

Three

BIRTH OF ROMEOVILLE

The plat of Romeo was recorded on September 14, 1835, at the Cook County Courthouse. There is controversy over the date when the name changed to Romeoville. It was either in 1845, when Juliet became Joliet, or in 1895, when the village was incorporated.

After the I&M Canal opened for business in 1848, work began on the Chicago Sanitary and Ship Canal, which also followed the Des Plaines River. A jail was built at Romeo Road to hold riotous canal workers. Railroads began running through Romeo in 1854. In 1886, the Santa Fe acquired the railroad and built Romeo depot, which was used for half a century.

At John Miller's Barbershop in January 1895, the residents voted 42 to 20 to incorporate the village. Louis Hamann was elected the first president a month later. Meetings were held in a chicken house until the village hall was built.

Romeo children had an ideal childhood of games, swimming, and picking berries to sell to visitors. In the winter, they skated on the Santa Fe Quarry and sledded on the 135th Street hill. Boys trapped muskrats and hunted pheasants and rabbits. Young women were members of the Romeo Aces softball team. Young men played on the DuPage Tigers, the Lemont Tigers baseball team, or both. According to longtime residents Gladys Startz Hakey and Mildred Startz Drdak, members of the third generation helped plan and build all the Valley View schools in Hampton Park and the Union Oil and Commonwealth Edison plants.

Romeoville's population declined to 180 residents in 1939 and to 147 in 1950 in a small cluster of homes near New Avenue and on the island. Most of the local residents lived on farms in DuPage and Lockport Townships.

Residents of Old Romeo had close ties, with many marriages between families. According to Gladys Startz Hakey, a reunion of the Old Romeo families started in 1972 and was held annually into the 2000s.

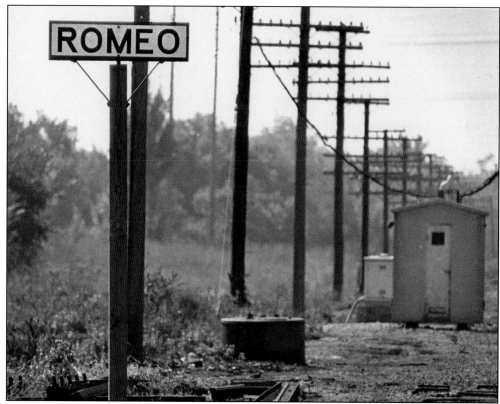

The sign at the switching station on the railroad left no one in doubt about where they had arrived. This was Romeo on the route to Juliet, which had already been renamed Joliet. Below, depot manager Anthony Startz, right, and an assistant staffed the Santa Fe Railroad station near 135th Street in Romeo. During an outbreak of smallpox, Anthony's brother Joseph Startz was reappointed magistrate and assigned the job of ensuring that no one got on or off the train so the disease would not spread further. (Both, RAHS.)

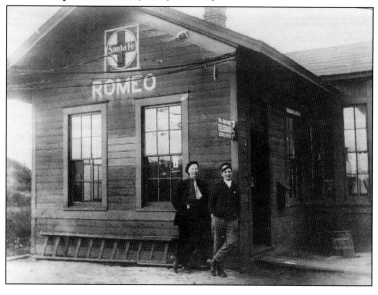

Lloyd Eichelberger owned this house, shown as it appeared in 1984. He and his wife Eileen raised four children here. Lloyd was a World War II Army veteran. His son James was a village trustee and an officer in the Greater Romeoville Chamber of Commerce. James managed a local auto parts store that became a branch of CarQuest.

This small chicken house was the first building used for village board meetings after the village was incorporated and officers were elected in 1895. The property where the chicken house was located would be the site of the Romeo Village Hall for more than 55 years until Hampton Park was established.

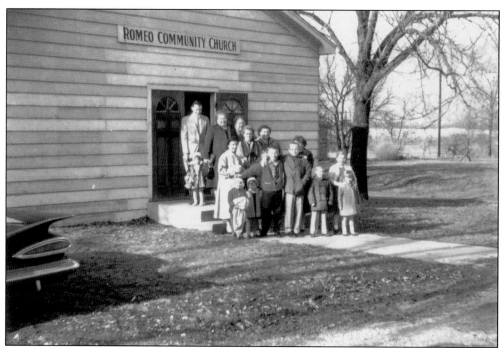

A nondenominational Sunday school began in 1937 on High Road. It grew into a small church and was chartered in 1946 as the Romeo Community Church. In 1968, it was renamed the High Road Bible Church. Fundamental Christian beliefs in one God and His Son, who is fully God and fully man, are the foundation of this church. Members assist in all aspects of church life, from cleaning and repairing the building to outreach to the community. The building has been enlarged and remodeled but retains the charm of a simple country church. It is the oldest church in Romeoville. (Above, courtesy of High Road Bible Church.)

Homes were erected on New Avenue overlooking the Des Plaines River at Romeo Road in the early 1900s. There was a great turnover of owners due to the economy. In 1922, the occupants became permanent residents. From left to right are Mitchell's Garage and the homes of Frank Zager, Matthew Berich, Oscar Wenberg, and the Heinz family.

Frank and Pauline Zager moved from Copper City, Michigan, around 1924 to a home on New Avenue with their children Frank, William, and Lucille, and grandson James Jordan.

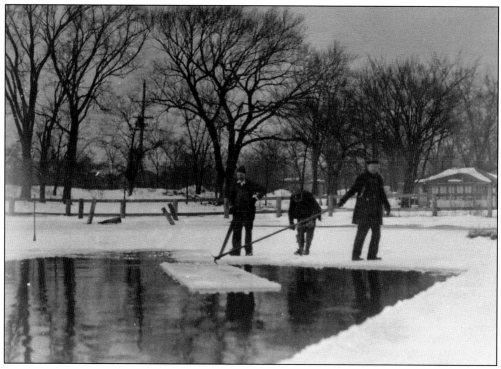

Ebenezer Bruce allowed the Bruce Quarry to fill with spring water and converted it into Clearwater Lake, part of which became Romeo Beach. With a bathhouse, parking, and a quick lunch counter, it was a favorite getaway for people from Chicago and neighboring towns. During the winter, ice was cut there and stored it for use in iceboxes and for cold drinks in the summer. Pictured in the 1930s, Roy Hassert is the cutter on the left; the others are unidentified. In 1978, the Romeoville village board approved the purchase of Romeo Beach from Commonwealth Edison for $100.

Some of the nine Schrader children are enjoying a swim in the Santa Fe Quarry. From the left, they are Howard, Florence, and Augusta. Cold quarry water was refreshing on a hot summer day. The high quarry walls can be seen in the background. Howard lived on the Island, then moved to Romeo Road near High Road.

The Santa Fe Quarry was also turned into a beach. The Civilian Conservation Corps built a pool there in the 1930s. It retained the feel of a quarry with its stone walls and overhanging trees. In the picture, it appears to have a shallower area dammed off on the right.

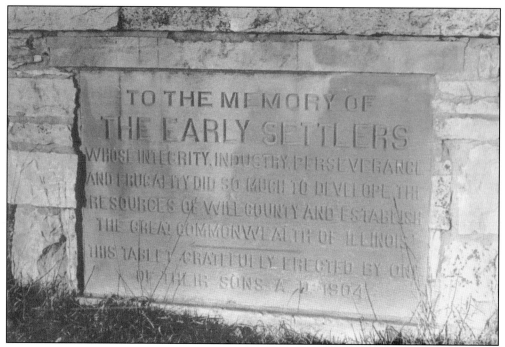

Pictured above, James H. Alexander placed this monument to the memory of the early settlers on the family farm near Romeo Road in 1904, next to a traveler's stone with the distances to neighboring towns. It disappeared when Hampton Park was built. Years later, Dorothy Hassert learned that a bulldozer from the Alexander (no relation) Construction Company knocked the wall and stones over and threw them into a ditch. Seen below, in 1991, the Alexander family presented a framed copy of the memorial to the historical society. From left to right, in front, are Michael "Mike" Stucko, Mary Stucko, and Mary Pell Alexander. Standing are Benjamin "Ben" Alexander, Jeanne Durrer, Marianne Alexander Hamrick, Ruth Alexander Durrer, Elizabeth Alexander Stucko, Jack Stucko, Carol Alexander Wicburg, and Thomas Haller Jr.

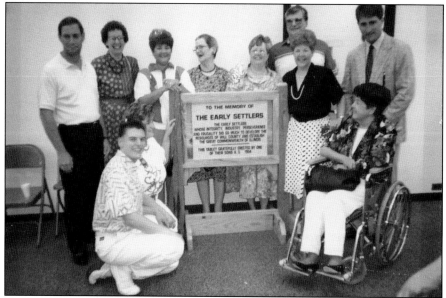

Globe Oil Company built this house for Superintendent Overton, the head of the refinery. Various managers of the company occupied it. The Charles Demmick family bought the house and moved it from the tank farm on 127th Street to High Road.

The Pounovich homestead was a 1922 Sears, Roebuck & Co. house, with pieces cut at the factory and numbered for local carpenters to assemble on the property. They did not know then that a more sophisticated version with entire walls built in the factory and installed by a team trained by the company would result in the rapid establishment of Hampton Park 35 years later. This photograph was taken in 1996.

The families from old Romeo gathered annually for a picnic with good food, friends, and games. Original residents brought their children and grandchildren At the July 1991 reunion, Robert "Bob" and Millie Startz Drdak, left, enjoy talking with Eva and Frank Bonkolski. The 31st reunion was held in 2003.

According to picture captions, the same men mentioned as the cooks handled the pig roast and other meats at each reunion. They are identified in this picture from the July 1991 reunion as, from left to right, William "Billy" Startz, Fritz Boehme, Leonard Heeg, Robert "Bob" Drdak, Edward "Ed" Pavolich, and Emil Fracaro.

Four

OLD-FASHIONED FARMING

Early Romeo's economy depended upon the numerous local prairie farms in DuPage and Lockport Townships during the 1830s and 1840s. Romeo, like other canal towns, provided goods and services to the farmers and provided access to market their produce.

Col. George Martin, who supervised the canal construction, built a limestone granary. With the completion of the canal in 1848 and the local granary, farmers could export their harvest on mule-drawn barges. Another granary, built in the late 1800s and known as the Lockport DuPage Farmers Elevator around 1920, operated more than 100 years before closing in 1997. Its 1882 account book lists the Clark, Heeg, Patterson, Weinhold, Williams, Eichelberger, and Varley families.

Romeo was located on two rail lines. The Alton line to Chicago began in the mid-1860s. The Santa Fe Railroad gave the village a second line in the 1880s. Each railway built a platform in Romeoville during the early 1900s to pick up livestock, produce, and milk from local farmers.

Farms occupied the majority of the area for more than 100 years. The Fitzpatrick, Farrell, Bachman, Ward, Hassert, Alexander, Phelps, Biggins, Lambert, McCoy, Jungles, and Daley families fill the rural history of old Romeoville.

Howard Hassert, whose family settled in DuPage Township in the 1860s, wrote that most farmers had dairy cows and shipped milk by rail to Chicago from Lemont or Romeo. They hauled eight- or ten-gallon cans by horse and wagon to the stations. A sign on each can identified the milk producer and the can's owner.

Thomas Sprague owned one of the largest and most successful dairy operations. He arrived in 1837, bought an 800-acre farm in Dupage Township, and established a butter and cheese factory. Later, he and his brother Frank purchased more than 500 acres in Lockport Township. They ran Sprague Dairy, which processed their milk and milk from other dairy farmers.

Change began in the late 1950s. More than 600 acres of farmland, soon followed by another 400 acres, were sold to develop Hampton Park. Homes and industry have erased farms from the landscape. Today, one can drive across the expanded village and never pass a single farm.

Elizabeth Jungels Eichelberger stands in front of the Jungels farm on Route 66A south of Route 66. Later, Earl Meisinger lived there with his family. In the 1970s, it was the site of Old Chicago, which closed in March 1980. After the building was demolished, the Arena Auto Auction filled the area with used fleet cars to be auctioned.

The James Williams farm was on Route 66A about a fourth of a mile south of Romeo Road. James is believed to be working the equipment in this picture, which appeared in *Successful Farming* magazine in the 1940s as an advertisement for the manure bucket and track.

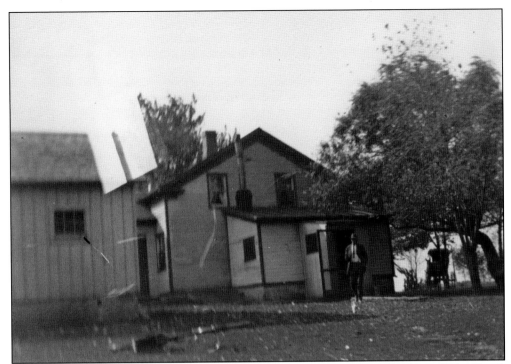

The Peter Grabow farm north of Route 66, between Naperville Road and the future Weber Road, was annexed by Romeoville in the 1970s when Bolingbrook and Romeoville were rushing to acquire farmland between the two villages. It became an industrial park in the 1990s.

This picturesque ruin of a farmhouse stood on either the Peter Grabow or the Harold Grabow family farm. The Harold Grabow farm was south of Route 66 and east of Naperville Road. As on many farms, nothing was wasted. When a new house was built, the old one became a storage shed until it disintegrated.

Four unidentified young women enjoy a snack that appears to be popcorn or Cracker Jack. Behind them on the left is a gas pump. On the right, above their heads, is the backstop from the baseball field. The building is the Mitchell store.

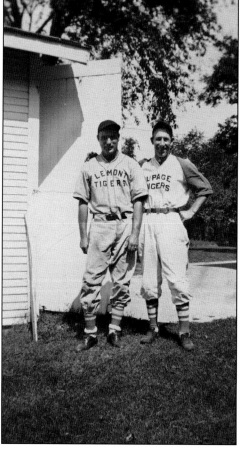

George Hassert, left, and Roman Kowalski played on the same team from the 1930s to 1950s. George played catcher, second base, and center field. George's brother Roy pitched and played first base. Note the names on their jerseys. George's uniform is for the Lemont Tigers; Roman wears the DuPage Tigers uniform. The teams played each other, but many of the same players were on both teams.

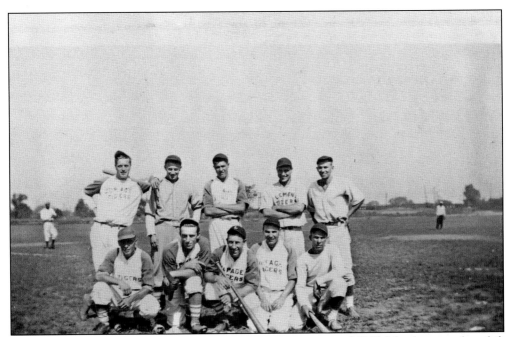

The Romeo Tigers team posed at Anthony Startz's tavern around 1933. Members are, from left to right, (first row) "Shorty" Scheldon, Steven Ward, William "Bill" Schrader, "Red" Bradley, Clarence McClain, and Michael Pounovich; (second row) manager Anthony "Tony" Startz, John Altman, Ray Dalhide, "Bus" Balstrode, Peter Ward, "Dutch" Gray, and Clayton Chilvers.

Fans of the Tigers engrossed in the game around 1947 are, from left to right, (first row) Emma Schumacher Konicek, Irene Blasing Weber, "Angie" Jungels Konicek, Marjorie "Mitzi" Konicek Weck, Grant Konicek, and Robert Konicek; (second row) Wayne Konicek and Ronald "Ron" Otto.

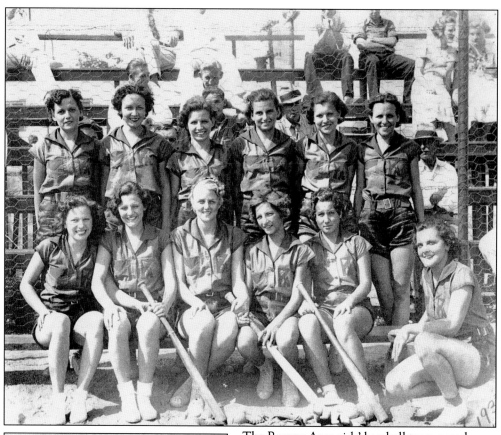

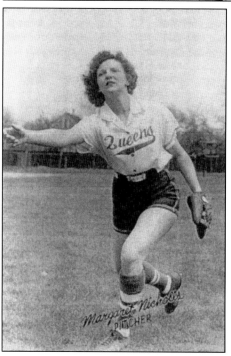

The Romeo Aces girls' baseball team posed at Rivals Park in 1937. From left to right are (first row) Audrey Morris, Margaret "Marge" Startz, Evelyn Murphy, Gladys Startz, Adeline Muelhausen, and Marie Pierce; (second row) Mary Pounovich, Mabel Fracaro, Jenny Pounovich, Helen Pounovich, "Marge" Pierce, and Martha Pounovich. They played for seven years. Margaret and Gladys Startz and Mabel Fracaro then played for the Chicago Hydrox team. Margaret Startz later pitched five evenings a week for the Rheingolds in Chicago, including an exhibition game at Madison Square Garden. Seen at left, the family kept Margaret Startz Nichols's baseball card to remember her prowess on the diamond. (RAHS.)

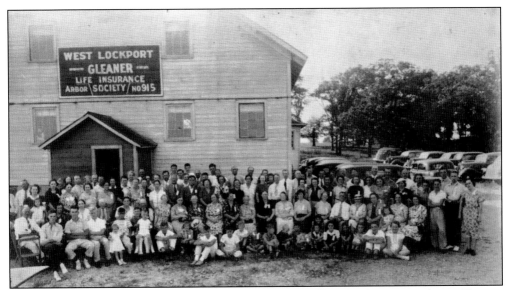

Gleaners Hall was built in 1922 at Route 66A and Naperville Road by the West Lockport Gleaners Society. The West Lockport area included the farms on the island and in the area that would become Hampton Park and later Romeoville. The hall was the social center of Romeoville during the farming era and into the beginning of Hampton Park. Parties, programs, and weddings were held in this largest building in the area. Those pictured above are unidentified. After it closed in 1961, fire departments participating in the Des Plaines Valley Mutual Aid agreement burned it in a cooperative training exercise. (Both, RAHS.)

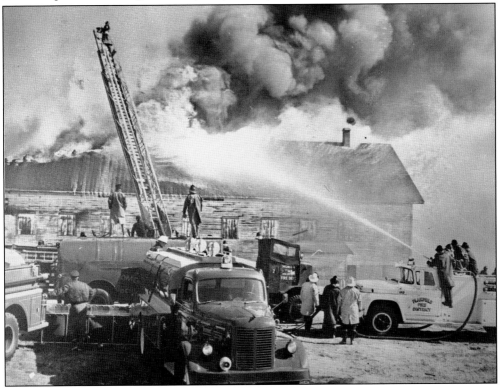

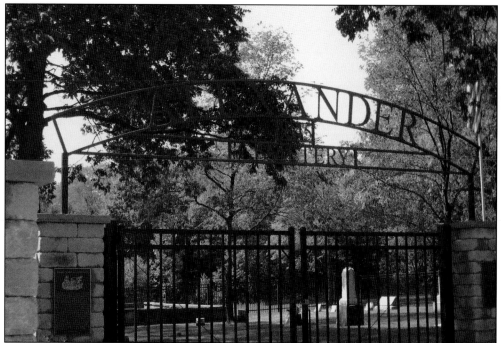

The Alexander family cemetery was on Route 66A north of their homestead. The wrought-iron gate with the family name designed into it demonstrates the pride and honor the children felt for their ancestors. James L., James H., and Healy Haywood Alexander are buried there with Healy's mother; his wife, Helen; his aunt Laura; his grandmother; and numerous other family members. It was also the final resting place for other local farm families. This is the same Alexander family that placed the memorial stone to early settlers. The picture below shows some of the family graves. Resurrection Cemetery was built next to it in 1958. (Both, RAHS.)

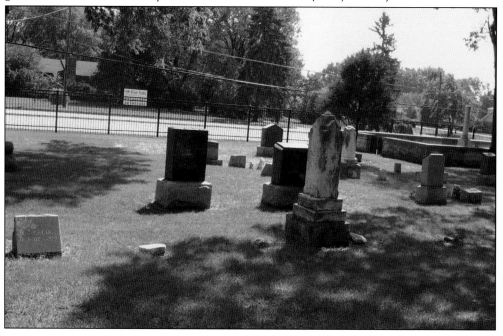

The Ray Homerding farm was on Romeo Road near Weber Road until the 1990s. In 2010, the third village hall was erected there. The recreation center had been built previously on adjoining property.

Patrick and Owen Biggins bought farmland on opposite sides of Normantown Road in 1848. Three years later, their brother James purchased land to the west of Owen's property. The Biggins family built this corncrib in 1903. Steven Homerding bought one of the Biggins farms. Later, Homerding sold the farm to the Santa Fe Railroad, which then demolished it in 2000.

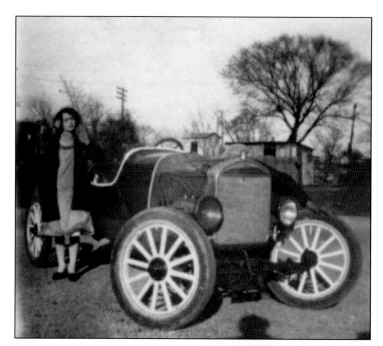

Ann (also recorded as "Anna") Pounovich Pesavento poses with a snazzy modern car. As the eldest of George and Martha Pounovich's 14 children, she helped with housework and care of the younger children. A ride in this car would have been a pleasant break, even if it was to run errands.

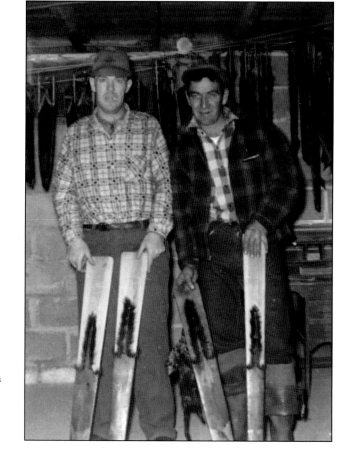

Mincer Gardner, left, and Steven Fracaro, both descendants of early settlers, display mink furs they trapped in the Romeoville area. Steven was the youngest of 10 children in the Fracaro family on High Road. For Steven, the minks were a business, meaning new clothes and food on the table.

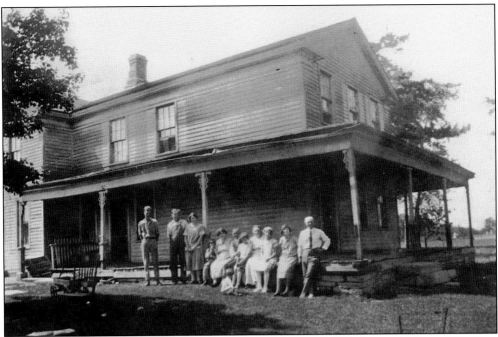

Kirman family members pose in front of their farmhouse on Route 53, previously Route 66A. They are (from left to right) Edward Vincent, George T. Kirman, Florence Vincent Kirman, Lorraine Kirman Otto, Elizabeth Vincent, Clayton Eaton, Marjorie Kirman Braasch, Nell Coby Kirman Eaton, Florence Kirman Reed, Mae Kirman Lambert, and Frederick Eaton. In the background on the right is the family cemetery. In the picture below, the Kirman farm in 1971 is viewed from the pasture. Behind the stone wall was the pig yard. The barn had a milking parlor on the lower level, with a two-story hay barn above. (Above, photograph by William Vincent; both, courtesy of Ronald Otto.)

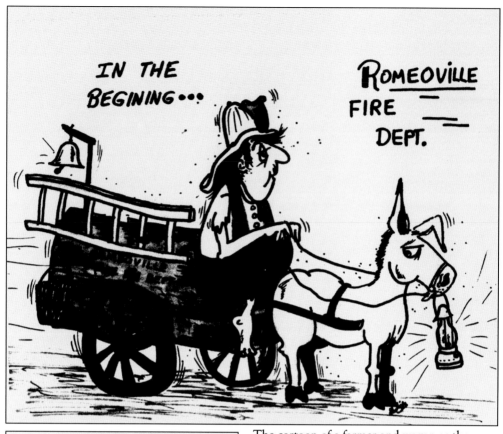

The cartoon of a farmer and wagon as the first Romeoville Fire Department fits perfectly with the farming history of the village; farmers quickly gathered with buckets to dip into wells or the river or used spades to dig dirt to extinguish fires. This cartoon is signed "Philip."

The old Peabody home was built in Reed's Crest of Hill east of Route 66A in 1931. This was the home of "Jack" Peabody, founder of the diner that would become White Fence Farm. Marvin Shikowitz, the caretaker of Hillcrest Park in Reed's Crest of Hill, stands in front of the home in 1986.

50

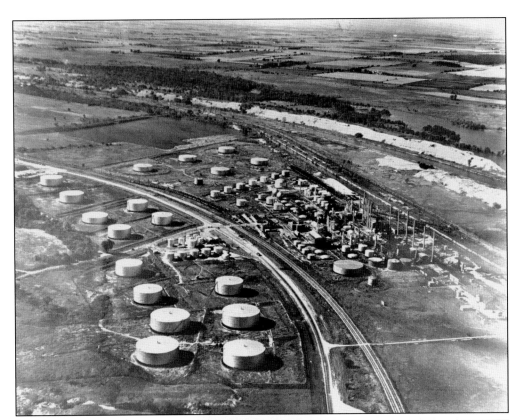

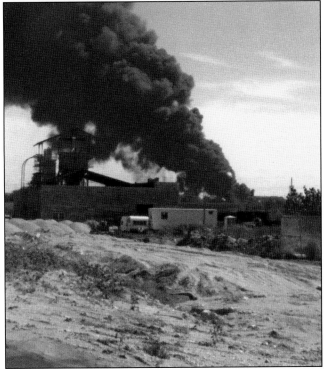

Looking west across the river and canal from Lemont shows the extent of the tank farm when it was Globe Oil and Refining Company/Lemont Refinery in 1948. Globe was one of the owners, followed by Pure Oil, Union Oil, and Citgo. The fields in the background became Hampton Park in the 1950s. An explosion and fire at the Union Oil tank farm east of the canal shook homes and broke windows as far away as Joliet. The services of fire departments from many neighboring towns were required, as shown at the right. Seventeen staff and firefighters were killed, and many were wounded before the fire was doused. Several smaller fires and explosions have also occurred since. (Both, RAHS.)

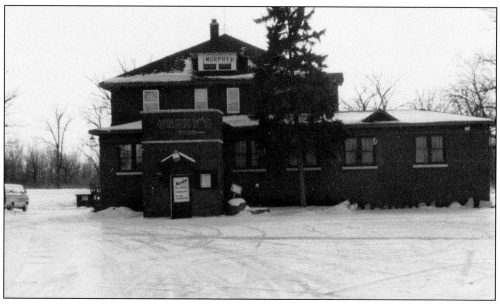

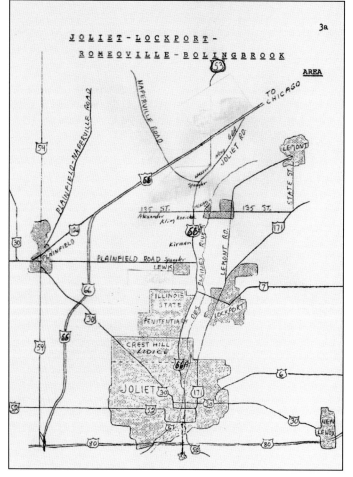

Neal Murphy rented the Boehme restaurant and then opened Murphy's Romeo Café on the island during Prohibition. He enlarged and remodeled it until it appeared like this, pictured around 1986. The tavern received national recognition for one of its special recipes, which was included in a cookbook.

This 1970 map is modified to show southern DuPage and northern Lockport Townships in 1957, with tiny Romeoville east of the river. Some farm families are noted. Stateville prison is prominent at the bottom of the map, west of Route 66A. Lewis Holy Name Aeronautical School appears north of the prison. The Kirman farm west of 66A north of Plainfield Road will become Lockport West High School.

Five

FARM SCHOOLS
TO COLLEGES

One-room schools, built on donated land, served the farm families in each township from the early 1800s until 1954. As farming declined and families became smaller, attendance dwindled. Records show that some teachers were paid by "student days," the number of students present each day. Four DuPage Township schools were in the Romeoville area. Three Lockport Township schools west of the canal joined in a 1952 consolidation. Detailed information on the schools is in *From One-Room Schools to District 365U DuPage Township, Will County, Illinois* by Dorothy Hassert, published by the Romeoville Area Historical Society in 2006.

Two parochial schools opened in early Hampton Park. Bible Baptist Christian Academy offers kindergarten through twelfth-grade schooling with a Christian emphasis. Saint Andrew the Apostle provides kindergarten through eighth-grade Catholic education.

In the early 1970s, legislation passed in Washington and Springfield encouraged high schools to build a county-wide vocational center to consolidate local programs with updated training methods and better equipment. According to former WILCO director Roger Claar, in 1976 the schools in Wilmington, Lemont, Braidwood, and Plainfield joined Valley View District in forming WILCO, the Will County Area Career Center. Sixty per cent of the construction and equipment funding came from state and federal sources. Genesis Health Care Institute specializes in training for careers in the medical field.

Romeoville is fortunate to have three colleges within its boundaries. Lewis Holy Name Aeronautical School opened in 1932 as a technical school with 100 male students. It evolved into Lewis College, and is now Lewis University, with aviation among its professional programs.

Joliet Junior College, begun in 1901, is the oldest public community college in the country. Beginning in 1975, the college rented space in Bolingbrook public buildings, then in Valley View School District's administrative center in 1982. The North Campus in Romeoville opened in 1993.

Rasmussen, the most recent college in Romeoville, opened in 2009 and received the village's "2012 Large Business of the Year" award. It offers day, evening, and online classes. Bachelor's and associate's degrees, diplomas, and certificates are available in the fields of business, education, design, health sciences, justice studies, and technology.

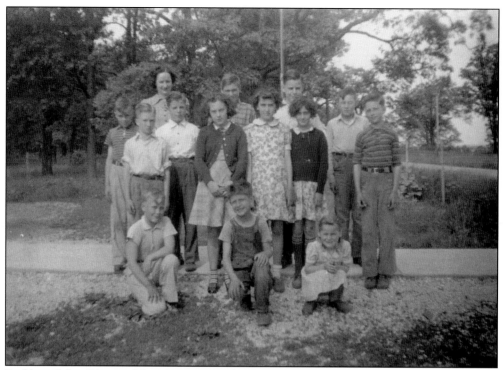

Burkhart School District No. 98 was on 127th Street in old Romeo. The earliest records are from 1862. Instead of the usual wood frame, the school was built of limestone because of its proximity to the quarries. Below, the 1938 students are, from front to back, (left row) Nadine Smith, Lois Heeg, Charles Wenberg, and Myra Twitchell; (second row) Kay Arthur McCabe, "Peggy" Pierce, Theresa Pierce, John Hensley, and "Jack" Smith; (third row) Rosemarie McCabe, Robert Souvener, Charles Heeg, Helen Hensley, and Alice Pounovich; (fourth row) Steven Fracaro, Della Pierce, Louis Pounovich, and William Twitchell. Teacher Ruth Ward is standing in back.

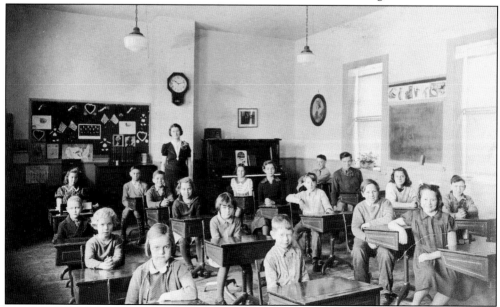

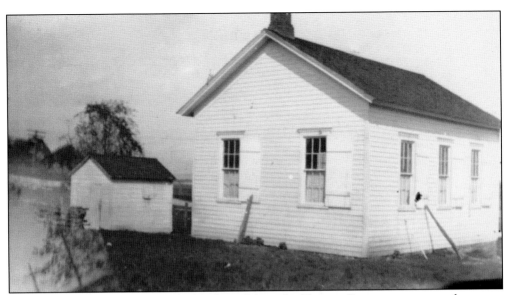

The Phelps/Sprague School was a typical wood-frame building on Sprague property at the corner of Naperville and Joliet Roads, today's Route 53 and Normantown Road, from around 1845 to 1959. In the records saved by Alice Spangler are copies of the monthly ledgers naming all the students attending the school and their attendance for the month. These records for the DuPage Township schools date from the 1820s.

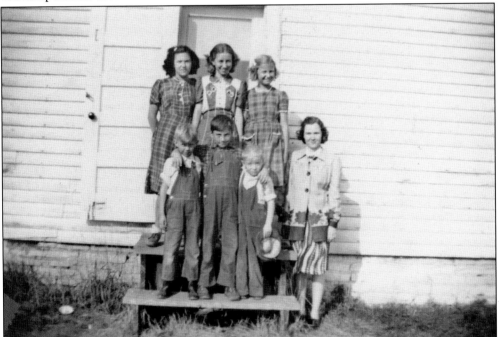

In 1891, there were only 10 children in the Graves School District in Lockport Township. The teacher was paid $26.66 per month. When the farm population dropped in the 1930s, some schools again had small classes. Two families attended Graves, but during the summer of 1934, the family with several children left the area. Since the teacher had a signed contract, she taught the only remaining boy for the next school year.

The wood-frame Taylor School in Lockport Township, located at Route 66A and Taylor Road, across from the current Romeoville High School, was built in 1840 and destroyed by a tornado in 1920. Rebuilt in 1923 with electric lights, plumbing, and a furnace room, it was the first modern school in Will County. Pictured below, members of the large c. 1907 Taylor School class are, from left to right, (first row) Bertha Ward, Joseph Ward, Anna Ward, Jane Williams, Katherine "Katie" Ward, Mary Ward, Gertrude Kirman, Loretta Ward, and Joseph Ward; (second row) Kate Williams, Thomas Kirman, Charles Eich, Al Kirman, unidentified, and George Reed; (third row) teacher Mae Moysten, unidentified, Thomas Williams, Leonard Ward, Frank Kirman, an unidentified janitor, Mayme Eich, Leonard Eich, and an unidentified teacher.

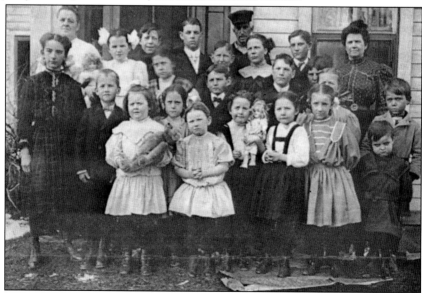

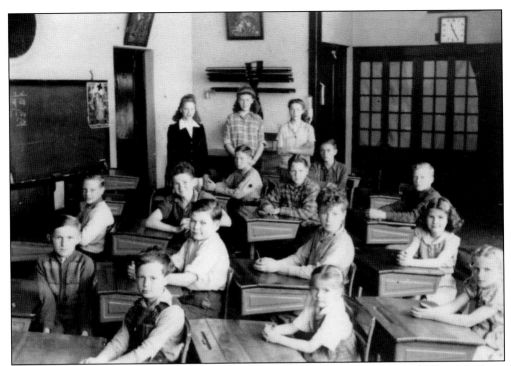

Taylor School students around 1945 are, from left to right, (first row) Donald Braasch, Joan Alexander, and Dolores "Dolly" Nikiel; (second row) Joseph Nikiel, Richard "Rick" Bromberek, Robert Braasch, and Marianne Alexander; (third row) John Gannaway, Alois Nikiel, Robert Hartman, and Charles Gannaway; (fourth row) Thomas Harnback and Harold Lindstrom; (fifth row) JoAnn Gannaway, Norma Lindstrom, and Jennifer Handcock. In 1954, it was remodeled into the Koch house and then into the Prehn law office.

The Hopkins School on Weber Road in Lockport Township operated from April 1948 until it closed with the consolidation in June 1952. No photograph is available of this school in use. Pictured is an example of uses for the schools after they closed. It became a house and later a florist shop, shown here in 1999.

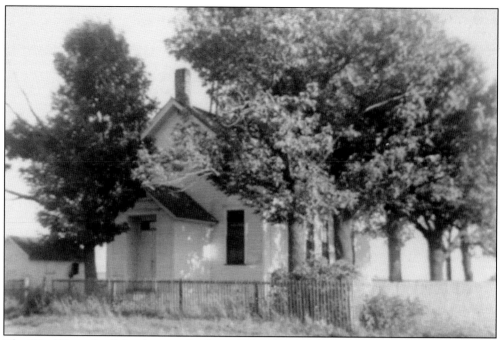

The Ward/Spangler School was in Lockport Township on the Ward Property at the corner of Weber and Taylor Roads. Pictured around 1925, these students are, from left to right, (first row) Marie Schmitz, Helen Ward, Angeline Schmitz, Grace Smith, Florence Titus, Ethel Smith, Iva Mae Schultz, unidentified, Leonard Titus, and Henry Schmitz; (second row) Charles Wright, Matthew Schmitz, Warren Titus, Frances Ward, Thoren Wright, and John Schmitz; (third row) Earl Ott, Raymond Ward, Ernest Schmitz, Charles Ashway, Irene Spangler, and teacher Nellie Reite. The building photograph was taken in 1999, which was 40 years after the country schools were closed.

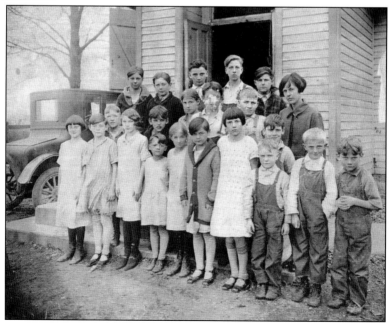

St. Andrew the Apostle school opened in 1959 for the first through sixth grades, with the seventh grade added in 1964 and eighth grade in 1965. It has provided education in the "Four Rs" since its inception. To the usual "Three Rs," religion was added. Although the first eighth-grade graduation was in 1966, the first class to complete eight years in the school graduated in 1967. Graduates then attend Joliet Catholic or Romeoville High. (Courtesy of St. Andrew the Apostle.)

Romeoville Christian Academy was organized as Bible View Christian Academy in 1972. The school was renamed Bible Baptist Christian Academy, then in 2008, became the Romeoville Christian Academy to represent its location and clarify its mission. Pictured from left to right are (first row) Jason Byers, Phyllicia Pagulayan, Allyson Smith, Nadia Olanrewaju, and Mark Tapiculin; (second row) Kai Buckner, Raegan Lader, Michaela Langnickel, Rachel Sturgill, Tanner Beattie, Emily Lader, and Avery Back; (third row) Hannah Davis and Zachary Allen.

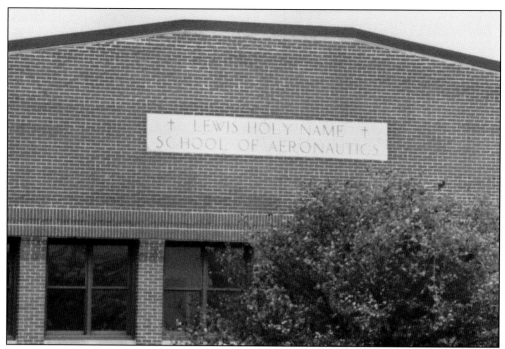

Lewis Holy Name Aeronautical School opened in 1932 as a technical school with 100 male students. During World War II, service men were trained there, and civilians welded targets for training gunmen in planes. It evolved into the comprehensive coed Lewis College and is now Lewis University, with 75 major undergraduate studies and several graduate degree programs. The drama department presents excellent plays at the school's Philip Lynch Theater, and its graduates work in theaters across the country. They staged the *Drowsy Chaperone* in 2012. Cast members pictured below are, from left to right, (first row) Erin Schneider, Jonah Schneider, and Jennifer "Jeni" Donahue; (second row) Robert James Cecott, Timothy "Tim" Tholl, Sam Juveland, and Jennifer "Jenny" Jasper. (Below, courtesy of the Philip Lynch Theater.)

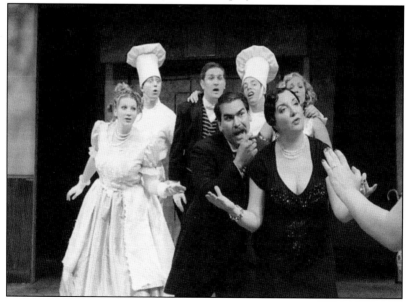

The Joliet Junior College is the oldest community college in the country. Its north campus opened in Romeoville near the intersection of 135th Street and Weber Road in 1993. Before the campus was built, the college rented space beginning in 1975 from the Fountaindale Library, the Village of Bolingbrook, and finally, the Valley View School District. Alice Herron was dean of the north campus throughout its changes in location.

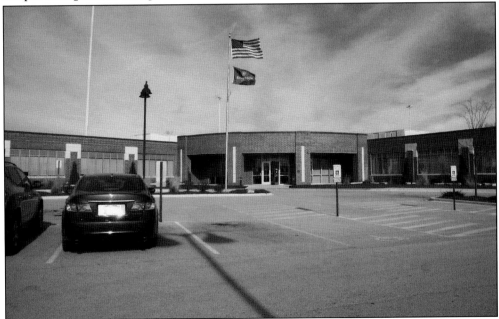

Rasmussen is an innovator in education, bringing practical, career-focused education to the classroom. The college is dedicated to serving the community by recognizing the diverse needs of individuals. They encourage personal and professional development through respect, appreciation, and a commitment to general education as a foundation for lifelong learning.

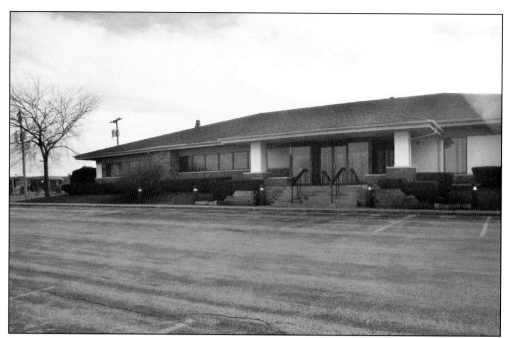

Genesis Health Care Institute supports a learning environment that will develop and launch its graduates into successful careers in the health care industry. It offers vocational courses such as nursing assistant, phlebotomy technician, medical billing and coding, and EKG technician for high school students as well as graduates.

The Will County Area Career Center (WILCO) serves high school juniors and seniors from Valley View and four other school districts in Will County in its Romeoville classrooms. The career or vocational program provides training in fields such as agriculture, welding, data processing, auto mechanics, and electronics.

Six

HOMES BUILT IN A DAY

In 1957, six hundred acres of farmland on the west bank of the Des Plaines River became Hampton Park. The population soared from under 200 in 1956 to 3,574 in 1960.

Alexander Construction Company displayed models on Arlington Drive in 1957. Homes sold for around $13,000, with monthly payments of $88.40. These prefabricated homes arrived on trucks with cranes. The builders put up 10 homes a day. As the gas company was not equipped to provide gas to every home, a lottery was held to obtain early gas hookups. Others had propane tanks in the backyard. A public phone at the corner of Arlington Drive and Fenton Avenue and another chained to an electric pole several blocks away provided telephone service in the first three months. When telephones were installed, only party lines were available. The Spangler farm at 66A and Normantown was a good landmark for visitors from the city.

The first homes were built on Fenton Avenue across the road from Gleaners Hall, the community gathering place. The Kinders and Frosts, the second and third families to move in, have been next-door neighbors for 50 years. Like many others, they bought their first house in Romeoville. Trucks delivered milk and bread daily. These staples were also available at Larry Tendell's Standard Gas Station on Route 66A and Romeo Road. Grocery stores were the A&P in Lockport and Tortura's or Ordmann's in Lemont.

The homeowners association was formed in the early 1960s. Since propane did not last three weeks in the cold weather, frequent deliveries were necessary. The new homeowners association managed to break the contracts for gas with the LP Gas Company. The association also was instrumental in forming the volunteer fire department.

A survey by the Romeoville Jaycees determined that there was an overwhelming need for a library. Joyce Kinder was active in the planning. The first library opened in Park View School in July 1971. James Bingle won the contest to name the library Fountaindale for the junction of the DuPage River branches. The Fountaindale Library buildings were completed in 1975.

Richard McKool, vice president of Alexander Construction, helps serve steaks at the grand opening celebration for the press. He is wearing a suit, and his tie reads, "Visit Hampton Park." McKool, Robert Alexander, and Neal Murphy filed the papers to start a bank. The original name for the bank was the First Bank of Hampton Park.

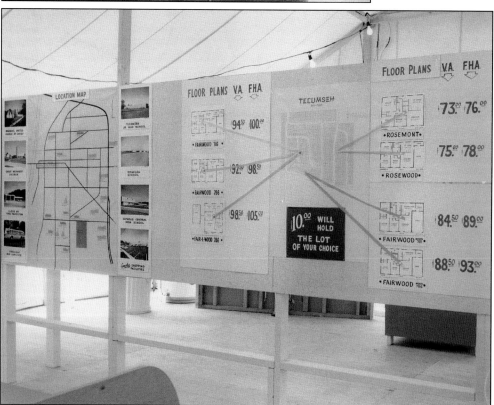

Signs at the sales tent describe the model homes and the options for location and prices. The proposed sites for schools and churches are shown in the small pictures on the left. The churches listed did not arrive, but several others, of various denominations, moved in during the first several years. Although the planned recreational area never materialized, a recreation center, with baseball and soccer fields, was built within a few years.

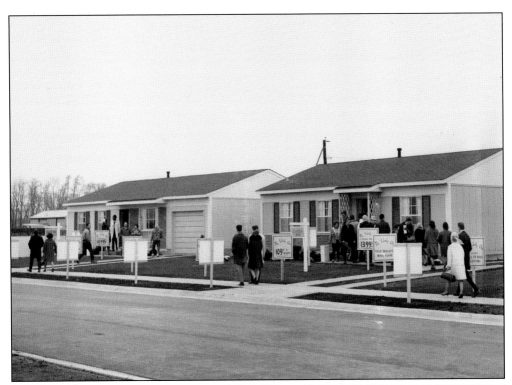

Prospective home owners came from all over the Midwest to tour the Hampton Park model homes on Arlington Drive after being enticed by the billboard on Route 55, which advertised "Hampton Park Alexander Construction NO DOWN PAYMENT to VETERANS. A planned community of 3 & 4 bedroom homes National Homes." In the first week, 192 homes were sold to enthusiastic buyers.

Each house arrived in a trailer with an attached crane to unload it. Doors and windows were preinstalled and the tile or carpet attached to the floor. After the foundations were poured and leveled, and the crawl spaces, sidewalks, and drives completed, 10 homes were built in a day. The day's installation included walls and roof, as well as attaching the plumbing, electricity, and heating to the crawl space connections.

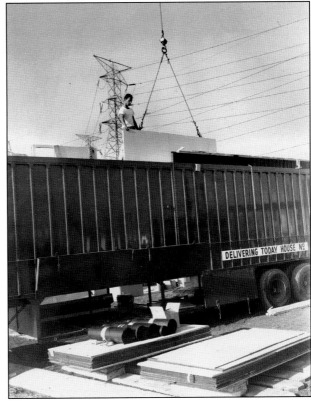

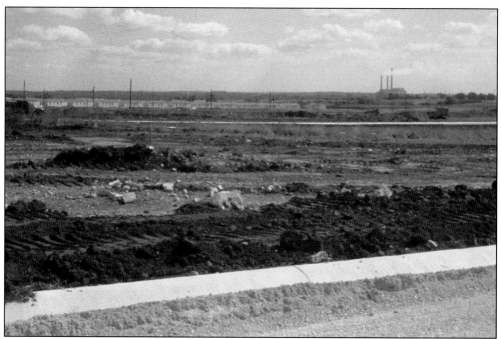

James Bingle took a series of pictures of the progress of his house. The view of the location of Hampton Park from his site in September 1958 shows a barren landscape with the power plant in the background. At 7:20 a.m. on January 29, 1959, when the house was brought in, the foundation, with utilities installed, was ready for the next stage. The homes were equipped with electric water heaters, and 100-amp electric service. Walls arrived with doors, windows, and electrical wiring installed at the factory. By 10:15, the same morning, the walls and roof trusses were installed. (Both, courtesy of James Bingle.)

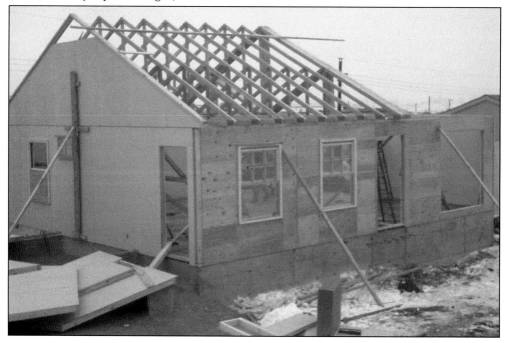

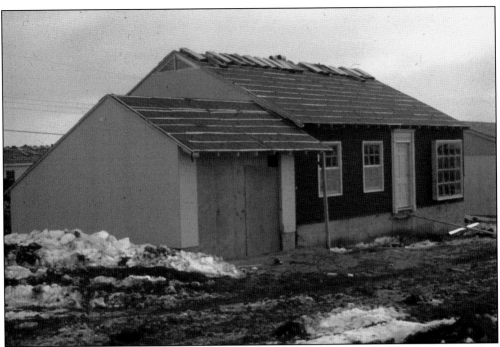

The roof was ready to be shingled by the time the crew finished at 3:40 in the afternoon. It then took several months for the interior crews to finish the home. The kitchens were wired for a washing machine. Gravel roads and driveways led to one-car garages, but there were sidewalks and paved walks to the front door and the incinerator. The builder even supplied a clothesline strung from the house to a pole or between two poles. James Bingle ended his photographic narrative with a picture of the same view as the August one, from his roof, in December 1959. (Both, courtesy of James Bingle.)

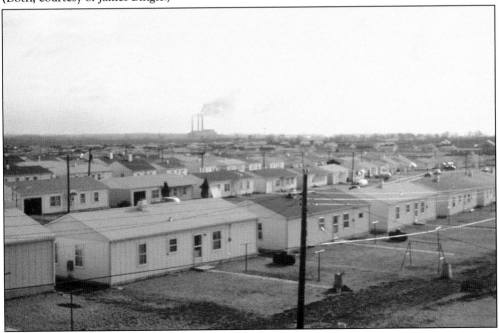

As utility services were not available immediately, each house was equipped with an incinerator to burn trash. This incinerator remains in the Page yard on Montrose Drive. Most houses had propane tanks in their backyards until gas hookups were available. A telephone booth at the corner of Arlington Drive and Fenton Avenue and another wired to a utility pole provided service to all. (JW.)

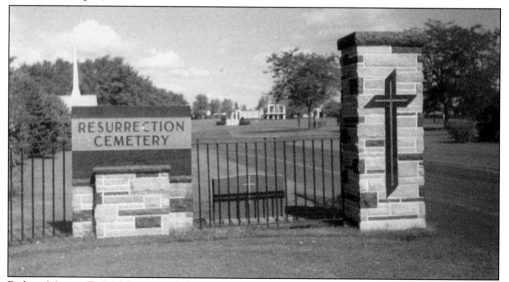

Bishop Martin D. McNamara of the Catholic Diocese of Joliet consecrated the Resurrection Cemetery on September 14, 1958. Located on Romeo Road at Route 53, the cemetery has spacious well-kept grounds with a mausoleum and individual plots. This photograph of the gates was taken in 1984.

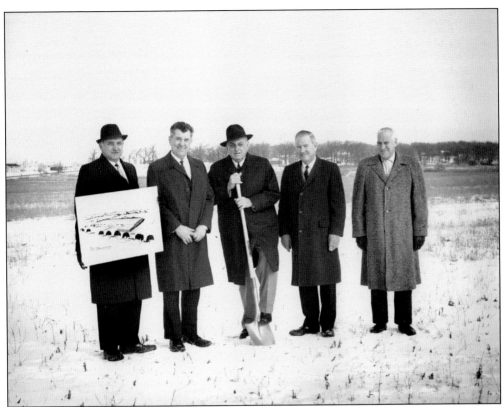

Officers of the Alexander Construction Company and National Homes and local officials break ground for the Hampton Park Industrial Park several years after the first subdivisions were completed. Pictured are, from left to right, Alexander Construction vice president Richard McKool, Lodd Salach, Mayor Neal Murphy, Alexander Construction president Robert Alexander, and Charles "Chuck" Vodicka.

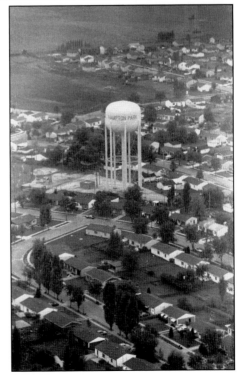

The Hampton Park water tower watches over some of the early homes in the village. In the flat Midwest, water towers are necessary to store water and provide pressure to move it to the homes, so one of the builders' first priorities was a tower. Community identification on the towers helps locate the town from a distance.

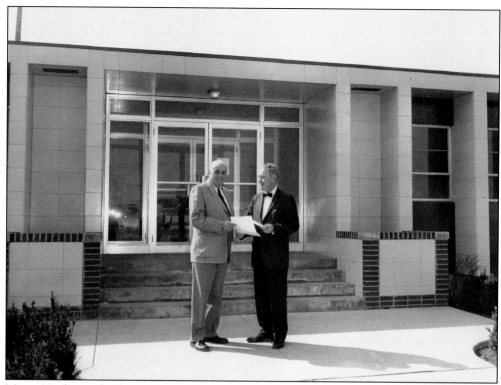

Mayor Neal Murphy, left, confers with Robert Alexander in front of the new Hampton Park Village Hall built by Alexander Construction Company in May 1960. This modern facility, with an attractive boardroom, replaced the small village hall that had served early Romeoville for 50 years. The photograph below shows the expanse of the building that housed all village departments in one location. The right end of the hall was the fire department garage, which held all the fire vehicles during the early years of the village. According to early residents, the construction company donated the building to the village. (Both, RAHS.)

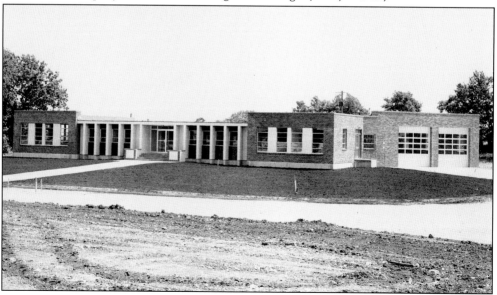

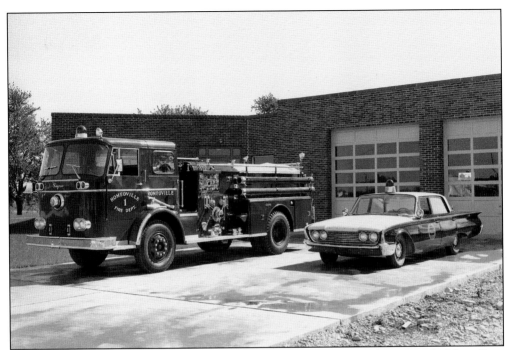

The Hampton Park Fire Department trucks were housed in a garage at the west end of the village hall. The large fins on the command car are proof that the photograph was taken in the late 1950s. When the fire department expanded into its own building on the other side of the street in 1976, the Romeoville Emergency Management Agency (REMA) moved into this garage.

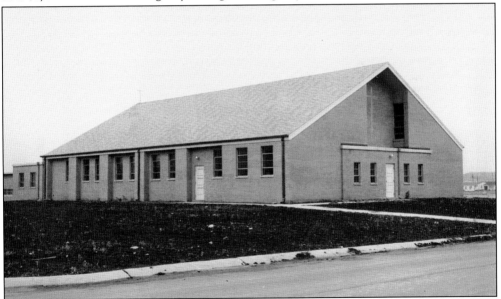

Rev. Joseph Jurhovich, a Joliet native, was appointed pastor of St. Andrew the Apostle parish in January 1959. Services were held at a church in Lockport or in the Lewis College Chapel until Mikan Construction built the church on Kingston Avenue. Robert Alexander donated most of the land and reduced the price on the rest. A school followed on the same property. The first Spanish mass was held in 1969.

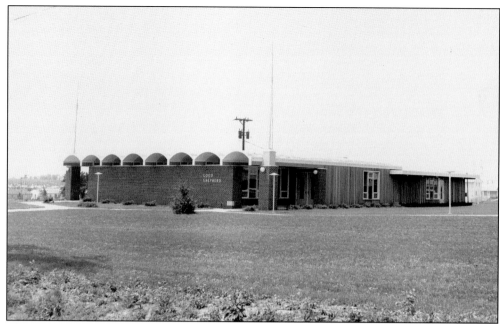

The Good Shepherd Lutheran Church, the second church in Hampton Park, chartered in 1961, held services at several places before settling at Normantown Road and Luther Drive. While there, the church had a kindergarten program, GRACE Thrift Store, Shepherd's Food Pantry, a Head Start program, and other ministries led by nine pastors. Many families of Romeoville and the surrounding communities contributed their time, talents, and offerings to the church. In 2007, the property was sold to the village to assist the downtown development, allowing the legacy of Good Shepherd to continue uplifting the importance of community in the church and the village. The picture below is of the first service at Park View School on July 24, 1960. The names of the congregants are not available. (Below, courtesy of Good Shepherd.)

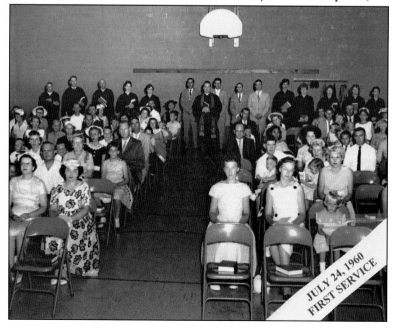

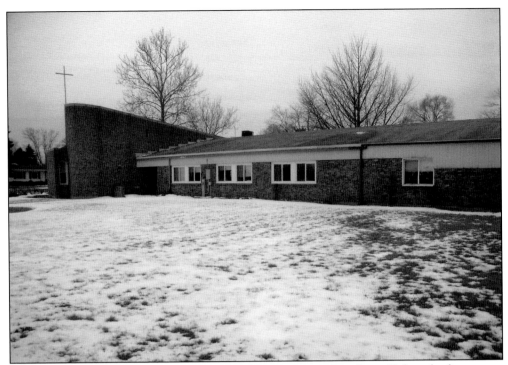

The United Presbyterian Church was the third congregation. Rev. James Fisher, the first pastor, remembers that partitions were left out of the manse so it could be used for meetings until a church was built. The congregation began to meet at Valley View School. Church members transported an organ to the school each Sunday morning. James Grant remembers having an organ to move and chairs to set up every week.

The Missionary Baptist Church on Route 53 at Honeytree Drive became the First Baptist Church. It was the fourth church in Hampton Park. This was an ideal location for a church because the highway, Route 66A, had been well traveled for years. It is currently the Love Fellowship Baptist Church.

In the fall of 1960, after numerous calls to many new housing projects around Chicago, Rev. Samuel Muralt came to Hampton Park. The McComb family started the church by opening their home for Bible study one night a week. On February 19, 1961, the first service was held. The church was incorporated as the Bible Baptist Church of Romeoville with 13 people signing as charter members on May 17, 1961.

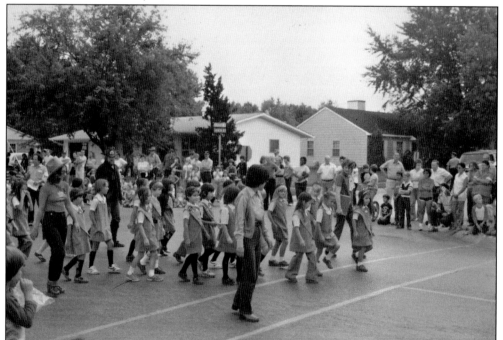

The Girl Scouts began in Romeoville in 1960. Many Girl Scout troops have been organized in Romeoville since that first troop, and troops are active at community events. Here, they are seen marching in a Founders Day parade in the 1970s led by the Brownie Girl Scout contingent.

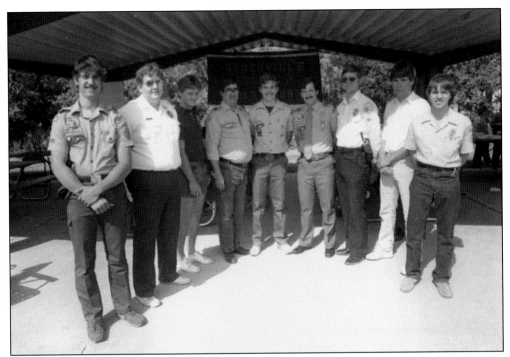

Boy Scout Troop No. 20 was chartered in November 1956. Joseph "Joe" Martinek, one of the founders, was Scoutmaster. Boy Scouts from Troop No. 20, around 1986, with staff from the police department and Romeoville Emergency Management Agency (REMA) are, from left to right, James Zarek, Michael Littrell, Wayne Littrell, Leonard Zarek, Edward Wisnowski, Jeffrey Senowick, Mark Littrell, Glen Littrell, and Michael Searcy.

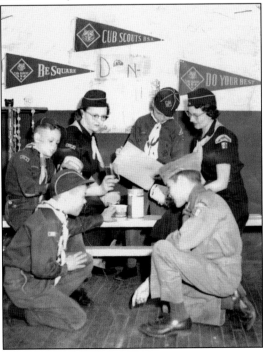

Troop No. 20 and Pack No. 20 were the first Boy Scout and Cub Scout troops in the area; they started shortly after Hampton Park was established. Cub Scout Pack No. 20 den mothers are Dorothy Hassert (left) and Barbara Dostal. Kneeling on the right is Boy Scout David Meisinger. The Cubs are unidentified members of farming and Hampton Park families. The pack celebrated its 50th anniversary at the Blue and Gold Banquet in 2008.

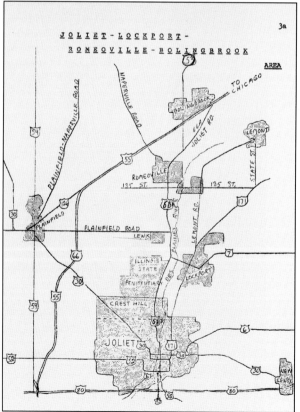

The police department moved into its own building in 1978. Separate from the other village departments, it was more secure. There was a small holding facility for prisoners. In 2010, the department moved into a wing of the third village hall with state-of-the-art communications. The old building was dedicated to Georgia Wilson and remodeled for the Tri-County Special Recreation Association, Romeoville Area Chamber of Commerce, and Romeoville Area Historical Society. (Courtesy of Valley View School District.)

This 1970 map is slightly modified to show southern DuPage and northern Lockport Townships in 1966. Route 66 is changing to Interstate 55, but 66A continues through Romeoville. Route 53 is a state road through the area on both the 1957 map on page 51 and this 1966 map. (Courtesy of Valley View School District and modified by Nancy Hackett.)

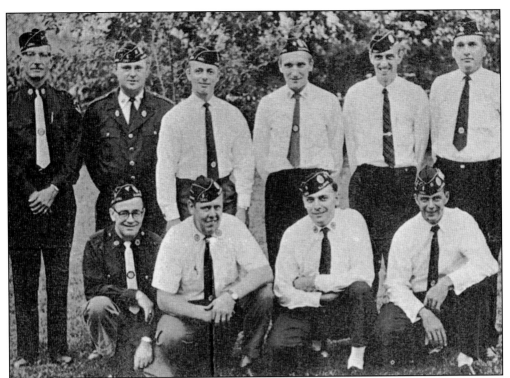

The officers of the Hampton Park Chapter No. 1261 of the American Legion posed at their installation. Kneeling are, from left to right, William Talbot, James Watkins, Commander George H. Wise, and Louis Trepto. Those standing are George Mersman, Clifford Eaton, Wayne Slurtz, Constantine Shaw, Harold Hoffman, and Robert "Bob" Phillips. The chapter closed, but a recently established chapter is active in the village. In the picture below, the officers of the Hampton Park Chapter No. 1261 of the American Legion Auxiliary posed at their installation held in conjunction with the legion. From left to right are Helen Wise, Nancy Young, Melba Eaton, Dorothy Mersman, Pres. Frances Talbot, Emma Seery, Patricia Hoffman, and Deloras White.

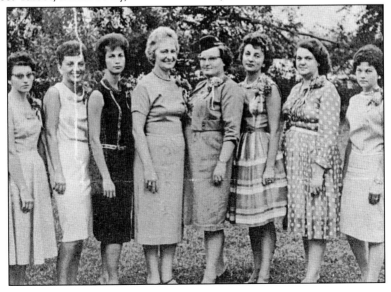

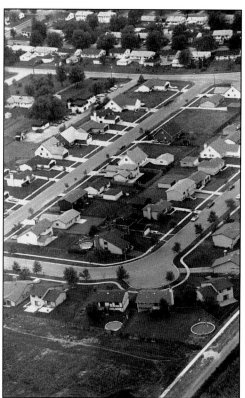

The homes of Honeytree subdivision were built following the extensive Hampton Park building project. Honeytree houses were larger, more expensive, and more varied than the Hampton Park tract homes to the west, seen at the top of the photograph, taken from the east.

The Romeoville Jaycees began in the mid-1960s, with Vito Martinez as the first president. They created the Romeoville Mosquito Abatement District, sponsored track and field, built the first lighted ball field in Romeoville, and completed other community-oriented projects. Their boxing club produced a Chicago Golden Gloves champion, Raymond Pahl. Jaycee presidents are, from left to right, Charles Mueller, Robert Drdak, Ronald Hopf, Charles Smith, and Jerry Capps. (Courtesy of Jerry Capps.)

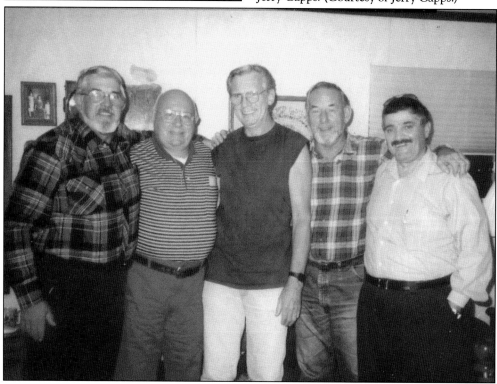

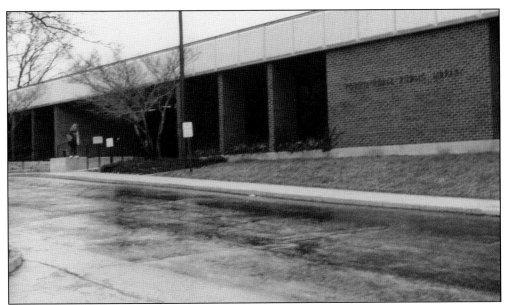

In the late 1960s, the Romeoville Jaycees formed a committee to establish a library district for DuPage Township. A referendum establishing the Fountaindale Library District was passed. The library opened in Romeoville's Park View School. In 1975, the library building opened, with a commitment from School District 365U to lease the lower level as their administrative center. Below, library director Alexander W. "Alex" Todd, Mayor Sandra "Sandy" Gulden, and Romeoville head librarian Nancy Hackett pose under the library's 25th anniversary logo in 1995. Alex directed the library from 1975 until his retirement in 1997. Nancy was head librarian in Romeoville from 1980 until she retired in 2000. In 2009, Romeoville split from the Fountaindale Library and joined Lockport and Crest Hill in the Des Plaines Valley Library District, which has since been named the White Oak Library District.

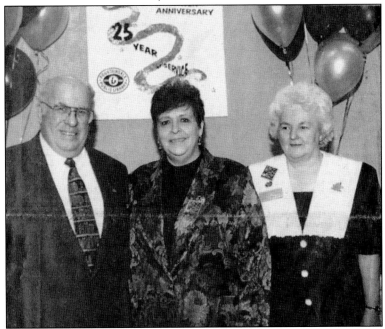

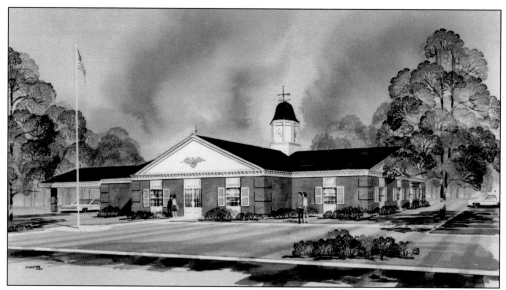

The Crawford Savings and Loan began on Town Hall Drive in the late 1950s. This architect's sketch is an accurate picture of the completed building, which has changed very little, except for the drive-up windows added on the left side. However, it has had several name changes and mergers since its inception. Its affiliation in the 2000s is with BMO/Harris Bank.

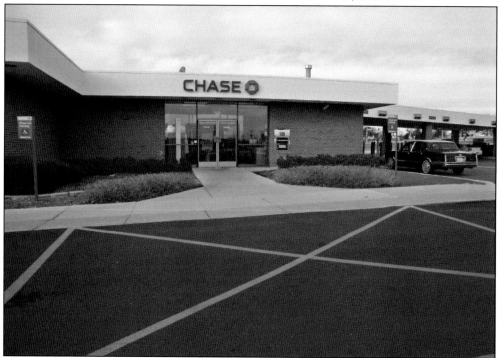

The locally organized First Bank of Hampton Park was chartered by Richard McKool, Mayor Neal Murphy, and Robert Alexander in 1970. It was renamed the First Bank of Romeoville. The bank has been enlarged twice by extensions to the left, and drive-up windows were added on the right. After name changes and mergers, it became Chase Bank. This photograph was taken after the most recent merger.

Seven

VALLEY VIEW SCHOOLS YEAR-ROUND

Valley View Elementary School, which was first through eighth grades, replaced all of the one-room schools west of the canal in DuPage and Lockport Townships. Donna Chilvers won a $25 savings bond for naming the school. When Hampton Park sales boomed, with matching growth to the north, additional schools were quickly built. Mandatory kindergarten added 660 children to the exceptional growth, requiring more schools. The names of all early schools in the district, which included Romeoville and Bolingbrook, contained the word View. Many early schools were renamed. Most of the schools built since 1974 were named for people.

Graduates from the one-room schools, and later those from Valley View School District, attended Lockport High School, then Lockport West, built in 1963. When the constant growth stretched the capacity of Lockport West High School, students there were placed on double shifts while Lockport High maintained a normal school day. This inequity led Lockport West to form its own high school district in 1970.

School overcrowding was a problem despite continuous building. Solutions such as half days were rejected. Patrick Page devised a new type of year-round school, which other school districts have adopted. Beginning in 1970, the area around each school was divided into four groups. All children in a neighborhood were on the same schedule. Students attended for 45 days, then had 15 days off while another group began their 45 days of school. Thus, 75 percent of the students were in school except during Christmas and spring breaks, and all had vacations in each season. Using this plan prevented half-day sessions and the expense of building more schools. Families liked vacations in the spring and fall, with better weather and less crowding at tourist sites. This system lasted from July 1970 through June 1980.

When growth slowed during the 1980s, the original Valley View School and a school in Bolingbrook closed. Another housing boom in the 1990s started the need for new schools again. Valley View School reopened. The new Kenneth Hermansen and Beverly Skoff Elementary Schools and John Lukancic Middle School eased the crowding.

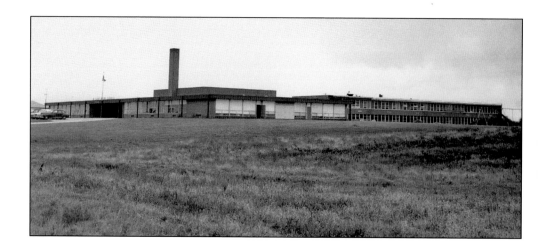

Valley View Elementary School opened in 1953 to replace the one-room schools. In the first year, there were 130 students from grades one through eight, seven teachers, with principal Kenneth Hermansen teaching sixth grade. By 1959, twenty-three more rooms were added to the original 12. It closed in the 1980s and one wing reopened for several years in the 1990s. While the school was closed, the administration center moved into part of the building from the Fountaindale Library where it had been located for 10 years in repayment for providing the land for the library. Below, Valley View School's first band poses in front of the school, ready for a concert in parade uniforms. The band director was Archer McAllister The first graduating class had 16 students. (Both, RAHS.)

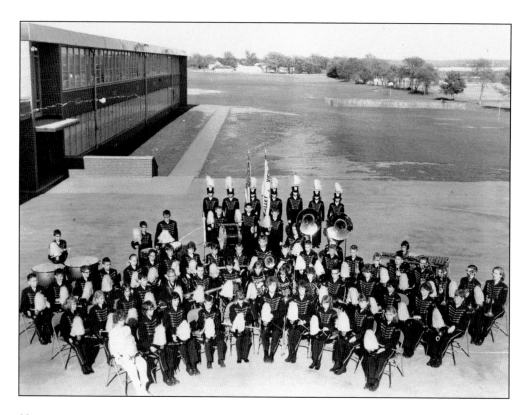

Park View School, opening in 1962 with 24 classrooms, was the second elementary school in Hampton Park and the Valley View district. It was an all-electric school, with air-conditioning, and more classrooms were added in 1964. It was renamed Robert C. Hill for the school's popular custodian who cared about the students, kept morale up for 18 years, and grew geraniums to brighten the classrooms.

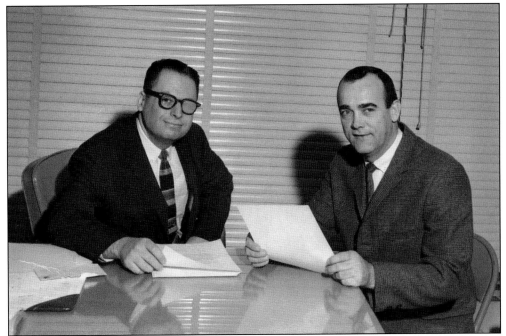

Dr. Irwin Widen (left), principal of Valley View School, and David Pauley, assistant principal of Park View School, are pictured in 1963–1964. They probably were discussing integrating dozens of new students into the classes or using the new Initial Teaching Alphabet in the reading and writing curriculum.

The rapid growth of Hampton Park and Bolingbrook created overcrowding. In 1963, Lockport West High was built on the Peter Ward farm on Route 66A for students from Romeoville, Bolingbrook, and Crest Hill. In 1970, it became a unit school district, renamed Romeoville High in 1972, then united with Valley View.

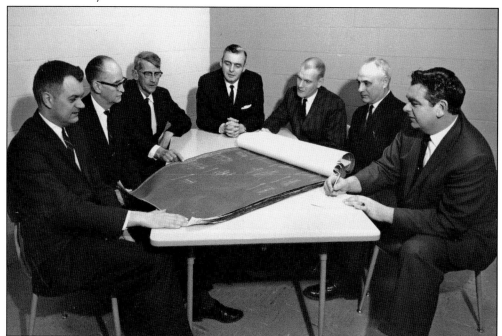

In 1963, the Valley View School Board considers the blueprints for North View, the third elementary school and the first school in Bolingbrook, which opened in 1964. Members, from left to right, are Harold Lindstrom, Erenesto "Ed" Edsal, Bernard "B.J." Ward, John "Jack" O Hara, John Strobbe, George Hassert, and Clark "Boz" Everhart.

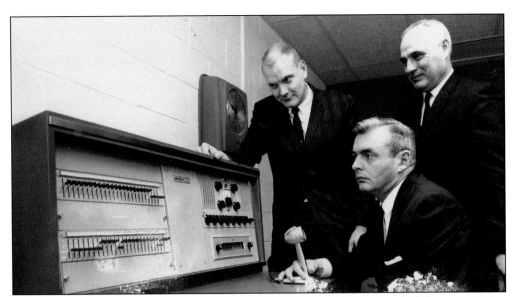

Members of the school board check out a new communications system around 1963 in preparation for equipping North View Elementary School in Bolingbrook, the next school to be built. From left to right are John Strobbe, George Hassert, and John "Jack" O'Hara. Later, Strobbe and O'Hara were elected mayors of Romeoville.

Valley View School District created the 45/15 plan for year-round school. The schedule was mailed to families each year. Note that the columns are three-week periods. Students attended for 45 days, and then had 15 days off. The area around each school was divided into four groups. Three groups attended school while one was on vacation. Families benefitted with vacations in the off-season with lower expenses, better weather, and smaller crowds.

VALLEY VIEW DIST. 365 II 1973-74 CALENDAR

| July 23 Aug. 10 | Aug. 13 Aug. 31 | Sept. 4 Sept.21 | Sept.24 Oct. 16 | Oct.17 Nov. 6 | Nov. 7 Nov.30 | Dec. 3 Dec.21 | Jan. 2 Jan.18 | Jan.21 Feb.15 | Feb. 18 Mar. 1 | Mar. 4 Mar. 22 | Mar.25 Apr.11 | Apr.15 May 3 | May 6 May 24 | May 28 June 14 |
15	15	14	16	15	16	15	13	19	10	15	14	15	15	14
A	A		A	A	A		A	A	A		A	A	A	
B	B	B		B	B	B		B	B	B		B	B	B
	C	C	C		C	C	C		C	C	C		C	C
D		D	D	D		D	D	D		D	D	D		D

ROMEOVILLE HIGH SCHOOL COURTESY OF AFT LOCAL

85

West View Junior High School was built in 1966 in the new open space design of pods, with the cafetorium as the hub. Classrooms had doors opening outside. It became a middle school with grades six through eight to alleviate crowding in the elementary schools. In 1991, it was renamed for A. Vito Martinez, who was president of the High School district from 1991 to 1992, then Valley View school board member from 1972 to 1987, and president from 1972 to 1981 and 1983 to 1987. At left, Karen Miraglia models the West View band uniform. (Left, courtesy of Joseph Miraglia.)

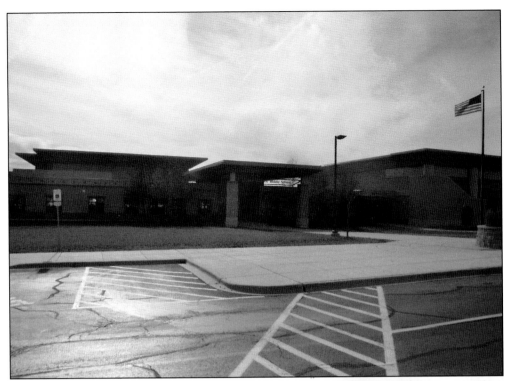

Ridge View Elementary School was the last of the Romeoville schools in the extensive original building program. It opened in 1969 and, in 1978, was renamed for Irene King. Irene King, pictured at right, taught at the Sprague and Chapman one-room schools before transferring with her students to Valley View School as one of its original teachers. She also taught at West View and Ridge View before retiring in 1975 after 26 years with the district. The school spelling bee she began at West View was later expanded to an intramural contest with the other middle schools and was also named for her. The students in their Halloween costumes are unidentified.

The John Lukancic and Beverly Skoff Schools appear from the east end of the complex. The John Lukancic Middle School is on the left, with the Beverly Skoff Elementary School on the right. The Beverly Skoff School below, named for the previous owner of the land, opened in 2005. It is attached to its twin, the 2006 John Lukancic Middle School, by a shared central section that can be utilized by either school for programs or classrooms as the student population increases and shifts. The entry canopy for the Lukancic School is the same as the one shown for Beverly Skoff School. (RAHS.)

John Lukancic was assistant principal at West View and then was an administrator for Valley View School District. He is seen at the school dedication in November 2006 with Dorothy Hassert, one of the founders of the Romeoville Historical Society. In the early years of the Valley View School District, Dorothy was chairman of the homeroom mothers in North View, Park View, and West View Schools. Seated on the right is Rose Breitwieser Bennett, whose brother Delbert was secretary of the first Valley View School Board. In the picture below, the band of John Lukancic Middle School is prepared to march in the Founders Day Parade.

The US Marine Corps Junior Reserve Officer Training Corps at Romeoville High School marches in the Founders Day Parade. The JROTC participates in the village's Memorial Day and Veterans Day celebrations and assists at school and village events as a color guard unit or in other capacities.

The southwestern expansion of Romeoville started another school building program. The Kenneth Hermansen School was named for the first sixth-grade teacher and principal of Valley View School. When the school became a district, Hermansen was the first superintendent, from 1957 to 1976. He then taught social studies in the high school. He served on several boards, including the Village of Romeoville, Fountaindale Library, and Loven Oven Bakery.

Eight

A DIVERSE COMMUNITY

Arriving in the 1800s to farm or work on the canals, families worked and participated in the community. New residents of Hampton Park came from established communities with different lifestyles. As the groups met and interacted at church and Gleaners Hall, they learned to appreciate their differences. A few families are highlighted.

Stephan Startz moved to Romeo from Austria in 1893. He started a bakery and then ran a tavern. The Startz family was active in Romeo from the late 1800s until the 1960s. Anthony was village president, trustee, and clerk, as well as justice of the peace and judge. Peter built a bakery and Romeo Tavern, which became Chick's Tavern.

Nicholas and Theresa Rigoni Fracaro came to High Road in the early 1900s. Nicholas died when a train hit his car, leaving Theresa with eight children. Theresa ran the farm and rented rooms, helped by the older children. Mabel Fracaro Hrpcha chronicled the life of early Romeo residents in *Romeoville*, published by the historical society. She remembers boiling and ironing clothes, pitching hay, and milking cows.

Harold Lindstrom moved to Romeoville in 1936. He caught snapping turtles in the river. His mother made soup out of the turtles and sold it at the Big White Tavern. He graduated from Taylor School with three classmates and then attended Lockport High. He was a member of the Valley View School District Board of Education.

George McAbee met Edith Barbee in the Oklahoma oil fields. They married before he joined the Army. He began working for the Oklahoma-Lemont refinery in 1922. Their son Kay Arthur became a noted organist who often performed on the Grand Barton organ at the Rialto Theater in Joliet and was active in restoring the organ.

The Kinders and Frosts were the second and third families to move into Hampton Park, on the 600 block of the first street, Fenton Avenue. They are still next-door neighbors and friends.

The Clancy family were early residents of Hampton Park, arriving in 1959. Stephen worked for the fire department and then became the fire chaplain. The fire department dedicated an engine in his name. His son Stephen also worked for the fire department. Another son, Brian, has been a village trustee since 2008.

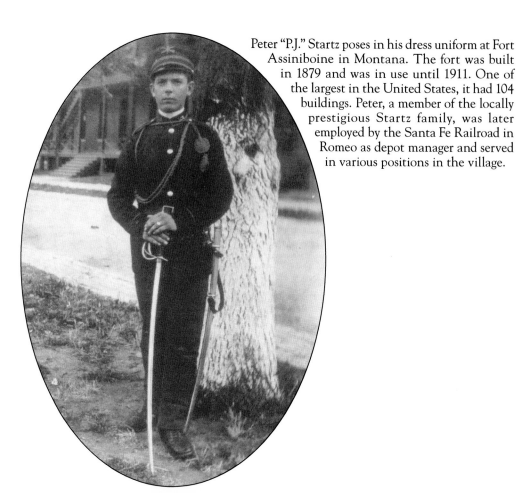

Peter "P.J." Startz poses in his dress uniform at Fort Assiniboine in Montana. The fort was built in 1879 and was in use until 1911. One of the largest in the United States, it had 104 buildings. Peter, a member of the locally prestigious Startz family, was later employed by the Santa Fe Railroad in Romeo as depot manager and served in various positions in the village.

Peter Startz Jr. proudly shows off his gun and catch to prove that he is ready to hunt at his father's hunting lodge. It is not known whether he actually shot the bird or if the picture was staged. The bird appears to be a pheasant or grouse, so the family ate well that evening.

Anna "Grandma" Startz sits with Robert "Bobby" Startz at the Ward farm on Route 66A in the 1920s. Bobby is the son of Anthony, who worked for the Santa Fe Railroad and served in the 39th Division in World War I. This farm became part of the grounds for Lockport West High School in the early 1960s.

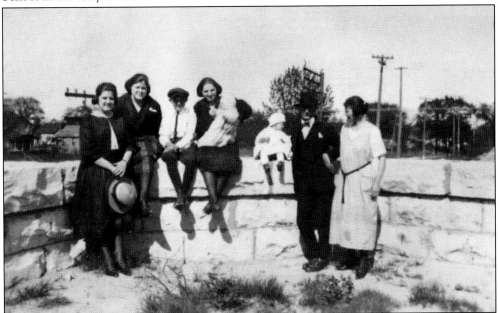

The Startz family sits on the wall of the old bridge. From left to right, they are Mildred Startz Allard Bellows, Mary Rodeghiero, unidentified, Luella Startz Pesavento holding Robert "Bobby" Startz, Marguerite Startz, and Anthony and Elizabeth "Liz" Wagner Startz.

John Pounovich was a village magistrate from 1938 to 1960, following his brother Nicholas "Nick," who had the position from 1934 to 1938. They, and their brothers George II and Michael, followed their father, George Pounovich, in working for the Santa Fe Railroad. This picture of John was taken in 1991.

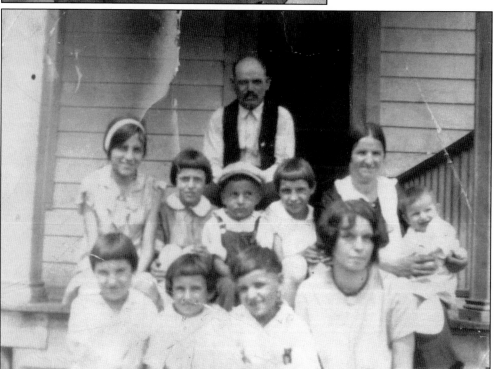

The George and Martha Pounovich family portrait shows 9 of their 14 children. Family members pictured are, from left to right, (first row) Rose, Helen, Daniel, and Anna; (second row) Martha, Mary, Louis, Jennie, and Martha holding Alice. George Sr., sitting in back, was a trustee, election judge, clerk, and road commissioner for early Romeoville. He also worked for the railroad between Lemont and Lockport for 49 years.

Pictured are Robert, Martha, and their son Thomas Williams. They had the determination of most families struggling through the hardships of farm life in the late 1800s. This is the same Williams family who owned the farm where Abraham Lincoln stayed for a week.

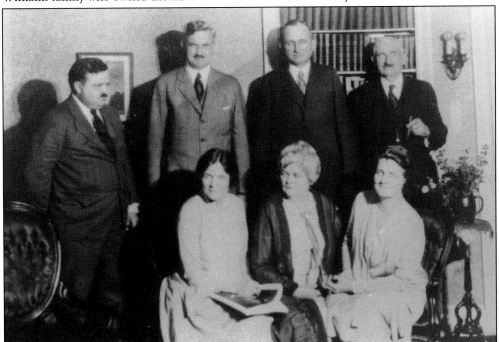

This Keig family portrait was taken after the children were grown. John J. Keig was born on the Isle of Man in 1858. In 1883, he married Mary Frances Lee and moved here. In 1886, he married Margaret Agnes McHugh, and they had five children who are pictured here with them. From left to right are (sitting) Ruth, Margaret, and Mabel; (standing) Joseph, Marshall, Robert, and John J. Keig.

The Anthony Ulmanek family moved to Romeoville around 1926. Pictured from left to right are Anthony and Mary standing, with Anthony Jr. and daughter Mary holding baby Mildred. An unidentified aunt stands on the far side of the buggy. After Anthony's death, Mary married Rudolph Nikiel, who worked in a quarry and later for the Elgin, Joliet & Eastern (EJ&E) Railroad.

Elizabeth Heeg relaxes on her porch with an unidentified young relative. The Heegs and Schraders, united through marriage, were well-known farmers with large families. It is probable that Elizabeth is the Elizabeth Seiler who married Frank Heeg. A prayer card states that she was born on August 1, 1884, and died on January 1, 1968.

Julius Dorich was a village trustee for 10 years. He worked for Reynolds Aluminum, then for Union Oil. He was also employed by the Village of Romeoville as director of public works beginning in 1960, when he was the sole member of the department until his retirement in 1979, when there were 20 employees.

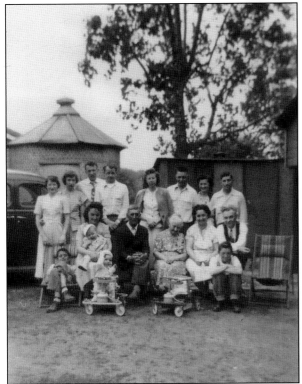

Several generations of the Dorich family members pose here. Pictured are, from left to right, (sitting) James, Mary Gecan Payla holding David Payla, James Budzinski in the stroller, Gaspar and Mary Dorich, Frances Dorich, Frank Gecan Jr., and Frank Gecan Sr.; (standing) Kay Gecan, Dorothy Gecan Remus, Richard "Dick" Remus, Howard Payla, Eleanor and Julius Dorich, Ann Dorich, and William "Bill" Budzinski.

Here, Anthon Pleshe appears to be ready to prepare potatoes for planting in 1946. Although a potato cutter had been invented, he either preferred to use the old method or could not afford the new contraption.

Cornelius Neal Murphy is seen with his mother, Mary, and father, Cornelius Sr., around 1899. Neal stands out from his plainly dressed parents in his high-buttoned shoes, knickers, ruffled shirt, and large tie. They are obviously proud of him even before his long term as Romeoville's mayor.

Ruth and Neal Murphy pose in front of their home. Neal was mayor of Romeoville for 40 years beginning in 1929. When he started, there were about 300 residents and a debt of $400, which was paid off immediately at his insistence. When he retired from office in 1969, the building boom of Hampton Park had swelled the population to more than 3,000. Neal died of a stroke at the age of 79.

Neal Murphy is proud of his daughters—Evelyn on the left and Lorraine "Sparky"—and of his historic car in the 1940s. He called this picture "Way Back When." Lorraine helped cut the ribbon on the new Romeo Road Bridge in the 1990s.

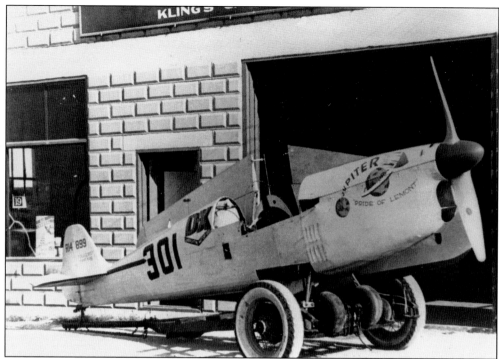

Rudolph Rudy Kling built his plane *Jupiter* in the family's garage on Route 66A, finishing it just in time for the 1937 Memorial Day race in St. Louis. The area was designated Lemont by the post office. Below, Rudy, in goggles and with a floral wreath around his neck, received a trophy on July 10, 1937, with his wife, Theresa, on the left. He went on to become the country's top airman at the National Air Races in Cleveland on Labor Day. He crashed with another plane in a race in Miami in December 1937. Both pilots were killed in the fiery crash.

The Senffner family lived west of the Alton Railroad and south of Romeo Road. They moved to the Rairdon subdivision in 1913 while George was a village trustee. The Senffner girls pose in a field. From left to right and oldest to youngest are Mary, Theresa, Frances, Violet, and Rose. Their oldest sister and only brother, born after Violet, are not pictured.

From left to right, Roy, George, and Howard Hassert, brothers involved in politics before Hampton Park, were instrumental in its growth. George was on the Valley View School District Board when the school population increased daily. Roy was a director of the one-room Sprague School, a DuPage Township supervisor, and a 30-year chair of the Will County Board. Howard worked to consolidate the one-room schools and was a member of the first Valley View School Board.

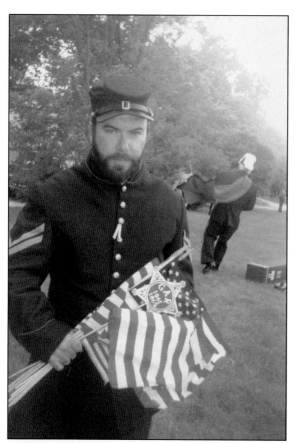

Daniel "Dan" Foran, wearing his replica Civil War uniform, places flags on the graves of veterans before the dedication of the first Veterans Memorial on Labor Day September 5, 1990. Dan is a member of the village's public works staff. In his hand is a memorial star with the inscription "G.A.R. 1861–1865."

Jerry Capps and David Carlson share a snack. Jerry, left, was a member of the village board for eight years and continues to be active in local politics, such as the Jaycees committee to build a library and the Friends of White Oak Library District. David Carlson was principal of Romeoville High School for 25 years and a member of the school board after he retired.

Nine

FAMILY BUSINESSES TO CORPORATE GIANTS

On Isle a la Cache, in old Romeo, and during the farming era, businesses were small family enterprises. There were many taverns, several restaurants, a hotel, beach cabins, and a small grocery store. Eateries changed owners and names over the years. Peabody's popular racetrack led him to open a restaurant, bought in 1954 by Robert Hastert Sr. Hastert's White Fence Farm, and Murphy's Romeoville Café attracted regular visitors from the Chicagoland area.

Residents bought their clothing, supplies, and most groceries in Lockport, Lemont, and at the Hillcrest shopping center in Crest Hill. When Hampton Park was built, a shopping center with a grocery, drugstore, Laundromat/dry cleaner, and liquor store was sufficient for basic shopping. Along Route 66A, small restaurants and carry-out shops appeared. Names of restaurants continued to change. The Cozy Cottage, expanded and renamed the Colonial Restaurant, was favored by village officials and high school staff. The Hilltop Restaurant became the Apollo, Boomerangs, On the Rocks, and Mongo McMichaels. Funny's was later Eggman's, Rosie's, and Eggman's again. The Bel-Air drive-in theater brought movies to Romeoville in 1950. Lou's Styling Place has served Romeoville women for over 40 years. The Loven Oven, a bakery staffed by people with special needs, created mouth-watering pastries.

The improvement of Weber Road and the construction of subdivisions on the west side of town in the 1990s started an influx of businesses there. Jewel grocery and Ace Hardware moved from Route 53. Chain stores such as Target, Menard's, Walmart, and Kohl's were built along the road. The two lanes widened into four and 17 traffic lights were added within four miles where there had been no stop signs. Fast-food chains and restaurants to feed the hungry shoppers followed.

Since 2010, redevelopment started at the "front door," Route 53, where business had slowed after the improvements on Weber Road. The Spartan Square shopping center, with only a few small businesses remaining, was demolished in 2013 to create a recreation-sports-shopping complex. Crazy Rock Lounge was also razed in 2013. In cooperation with the forest preserve, green areas are being created along the Route 66 corridor through town.

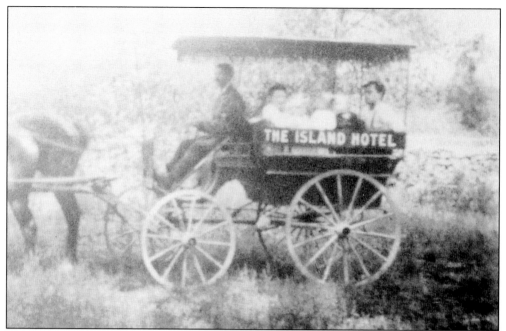

Joseph Startz drove a surrey to transport visitors from the railroad to his Island Hotel. It was a quaint form of transport and was well known by guests arriving from Chicago. The passengers in the picture, order unknown, are his children Emma, Luella, Mildred, and Edward and their cousin Anthony. Joseph Startz was village president from 1915 to 1919.

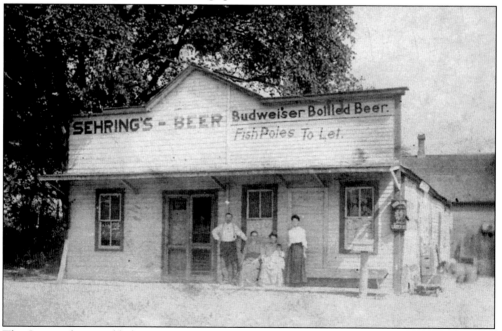

The Startz saloon and bakery was a popular site in old Romeo until a fire destroyed part of it in 1918. Stephen Startz turned the remaining part of the building into a saloon and small grocery. In front of the saloon are, from left to right, Stephen Startz Sr., Matilda "Libbie" Startz, Caroline "Carrie" Startz holding an unidentified baby, and Anna Startz.

Peter Startz built a two-story tavern and hotel on the island around 1920 after Stephen Startz's saloon burned. The tavern sold groceries and had a gasoline pump. The family lived in the back. In 1959, John Ulmanek and Anthony Fracaro bought it. In 1960 a fire destroyed the upper story, which was eliminated. The building was again damaged by the Union Oil explosion in 1984 and rebuilt as Chick's Tavern; it is pictured in 1996.

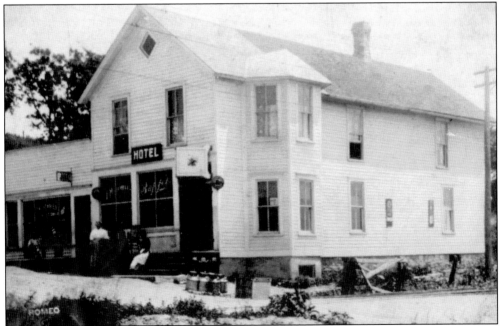

Louis Hamann built a saloon and grocery. When he left for California, his wife, Lorraine, ran the store. After she married John Mitchell, they renamed it the Mitchell Store and Hotel. They provided rooms for visitors to Romeo Beach. The one-story building is the grocery. It was a good location with easy access for farmers to send their milk to Chicago, as the streetcar ran in front of the store.

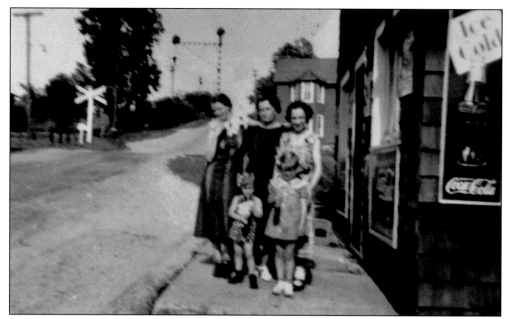

In 1895, an election held in Miller's Barbershop, which doubled as a meeting place, created the village of Romeoville. George Pounovich bought the building in 1931 for a tavern, which his brother Daniel ran. It eventually became Sarsfield's Tavern. The tavern was west of the railroad beside the Mitchell store seen in the background. Pictured, in no particular order, Ann McClain, her cousin Marie, and an unidentified woman pose with children Virginia and Charlene. The Boehme house and restaurant are on the left, east of the railroad.

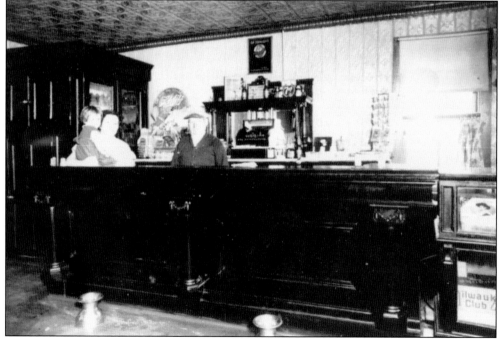

Ann Pounovich McClain and her daughter JoAnn visit with Daniel Pounovich behind the bar in the Pounovich/Sarsfield Tavern around 1943 after New Avenue was built.

The Lockport/DuPage Grain Elevator began prior to 1881. Arthur Weber purchased the majority of the shares in the 1930s. His son Howard "Bus" Weber became manager in 1945. The gristmill at the Lockport/DuPage Grain Elevator was destroyed by fire in 1951, but Arthur Weber rebuilt it. The granary appears as it looked in 1996. The gristmill is the tower on the left; the granary is the tower on the right. Union Oil Company acquired the property and destroyed it in the late 1990s. Below, Howard Weber stands beside the granary's antique cash register in 1996. The cash register was donated to the historical society after the granary closed. (Both, RAHS.)

Neal Murphy rented the Boehme restaurant, and then opened Murphy's Romeo Café on the island during Prohibition. The interior of Murphy's Café is seen as it appeared in 1986. The café, with its home cooking and the bar, were popular throughout the area. There was live music on the weekends. Neal's wife, Ruth, cooked and supervised the kitchen at the family-run café. Their daughters Evelyn and Lorraine "Sparky" helped cook from 1930 to 1950. Below, Raymond "Betsy" Cora tended bar with Neal Murphy in the 1930s. When the Isle a la Cache Museum first opened in the Murphy building, the bar was used as the reception desk. (Both, RAHS.)

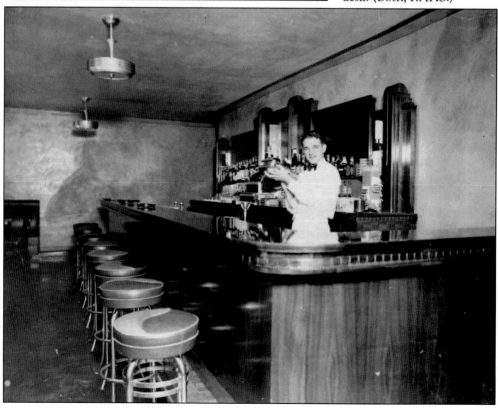

John Heeg, right, owned the Sinclair gas station on the east side of Route 66A at Romeo Road, one of the first businesses west of the canal. Later, he moved across the highway to sell Mobil gas and service. With him is mechanic Robert "Bob" Henderson. For 27 years, he permitted car wash fundraisers and helped anyone in need. John retired and sold the station in 1991.

The Hilltop Tavern later became the Apollo Family Restaurant until the name was changed to Boomerangs, followed by On the Rocks. While the Apollo, it was annexed into Romeoville in 1978. Since 2000, it has been remodeled and named for Steve "Mongo" McMichael, a former Chicago Bear.

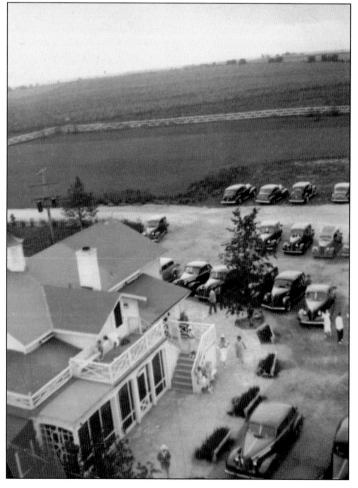

John "Jack" Peabody ran a racetrack at his farm. Since people watching the races wanted food, he opened a restaurant on Route 66A. In the spring of 1954, Robert and Doris Hastert purchased the farm, which then became White Fence Farm. They did extensive remodeling and enlarged it into one of the best-known restaurants in northern Illinois. The short menu features fried chicken and corn fritters. A museum in the lobby area displays clocks, dolls, and other antiques. The restaurant provides a petting zoo outside for young visitors. These views were taken between 1936 and 1942. Carry-out branches in neighboring towns also have a thriving business.

Robert Hastert's home was at the White Fence Farm on Joliet Road. In 1954, he bet friends that he could make a profit from Peabody's old burger shop. The original five dining rooms increased to twelve to meet the demand for his chicken dinners. His wife, Doris, was the hostess, and their daughter Laura worked there, eventually owning it. They gave many local youths their first jobs.

The Enco gas station on Route 66A at Naperville Road became a Rainbow Bread distributor. An early Hampton Park resident remembers that residents could pick up their bread and milk while they had their gas tanks filled. It later became only a bread store and then became Tuffy's automobile repair shop. The Romeoville Jaycees last used the building for a haunted house.

The Hampton Park Shell station on Route 66A, opened in July 1960 by Richard Haack, was one of the first businesses in Hampton Park and, according to the family, is the only one remaining. It was a clean, friendly gas station that offered full service, as shown by the repair bays on the right and in the picture below where (from left to right) Richard Haack Jr., Robert Heub, and Michael Wozniak provide full service to an unidentified driver getting a fill-up. The station still operates under the same name, benefitting the residents of Romeoville as a self-service station. (Above, photograph by MacDonald; both, courtesy of Laura Haack Soper.)

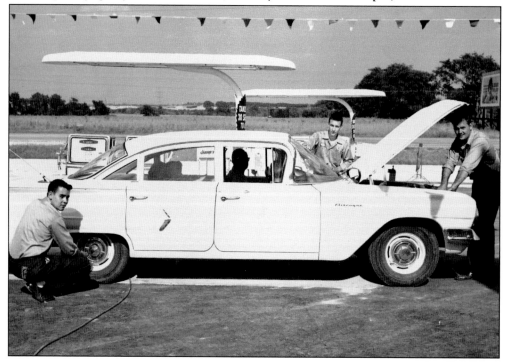

Hampton Park Terrace was built near Haack's Shell in 1964. When Caron Drugs left after a few years, the area was remodeled to accommodate smaller shops. Osco Drugs joined with Jewel, and a restaurant opened between Jewel and the laundry. The center was renamed Spartans Square for the high school Spartans. Jewel/Osco moved to a new shopping center in the 1990s, and Terrace Liquors moved out, but the laundry remained until 2013.

Lola Chambers opened Lola's Beauty Salon, the oldest salon in Romeoville, in 1961. It also served as the only barbershop in town. Lourdes Aguirre worked for Lola, and then took over the shop under the name Lou's Styling Place in 1988. At the 2013 "State of the Village Address," Mayor John Noak presented the Small Business of the Year Award to Lou's Styling Place.

The Loven Oven Bakery opened in the strip mall at Route 53 and Romeo Road. The manager was Beverly Canaday. The staff members were mainly people with disabilities. Their home-baked doughnuts and Danishes were regularly served at meetings and parties. The pizza-sized Danish was a favorite because it had about a dozen sections of different flavors so everyone could enjoy their favorite. Businesses had standing orders for their staff lunchrooms.

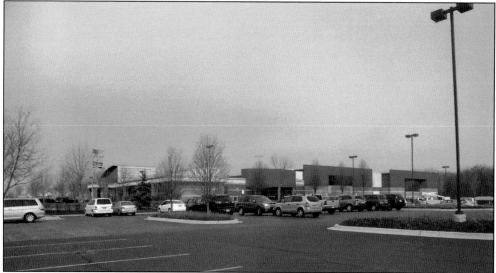

The original recreation department was demolished and replaced with this state-of-the-art building on January 11, 2002. It features a fitness center with a selection of workout machines, an area for preschool programs, and a center for senior citizens. The center hosts open-house sessions where village departments and nonprofit agencies can share information about their activities. Craft shows, community forums, and events for the family fill the calendar.

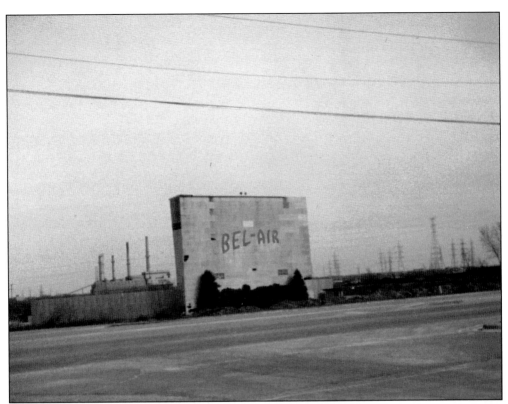

The Bel-Air drive-in opened in 1950. Located just south of Romeo Road, the Bel-Air was one of the eight drive-in theaters on old Route 66's trek through Illinois. It was a one-screen theater with a capacity of nearly 1,000 cars. The Bel-Air attracted theatergoers from Romeoville and many surrounding communities. After nearly 40 years of showing outdoor movies, the Bel-Air closed in the late 1980s.

Harold "Harry" Johnson opened Lost Acres in 1972. Anna Karuntzos bought it in 1976 and is still the owner of the enduring business. It is a comfortable local bar popular with residents. A traveling group of pool leagues uses the pool table. Wednesdays and Saturdays are karaoke nights. Local organizations hold fundraisers and raffles there to assist others.

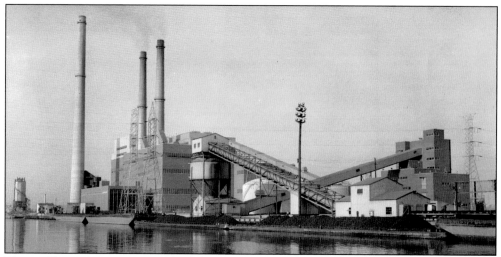

The coal-burning power station built by the Public Service Company became Commonwealth Edison (ComEd), which burned 10,000 tons of coal daily for every 1,000 megawatts in 1979. The station, now run by Midwest Generation, has been on 135th Street near the Des Plaines River since 1955.

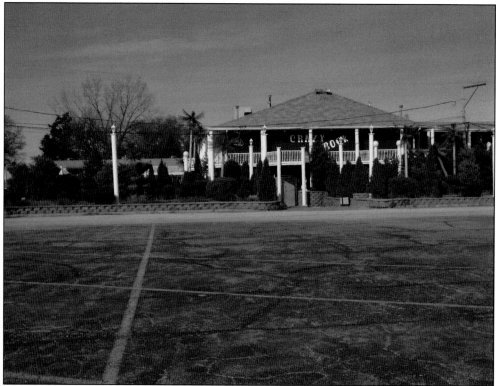

On Route 53, the Crazy Rock Lounge, later named the Crazy Rock Gentlemen's Club, was a popular bar outside the village limits. Owner Walter "Crazy Wally" Vincus began a Teen Night—without liquor—that attracted teens from a wide area. Crazy Wally generously donated to local clubs and charities. The lounge closed in the early 2000s and was demolished in 2012 as part of refurbishing the Route 53 corridor through Romeoville.

Ten

ROMEOVILLE TODAY

After the Hampton Park and Honeytree subdivisions were completed, the village of over 15,000 in 1980 enjoyed a peaceful existence without construction equipment. Several industrial parks were built east of the highway and north of town. Carillon, a senior housing development, was built west of Weber Road in the late 1970s. Increased use of the road led to an exit from Interstate 55 onto Weber Road in the 1980s, increasing the traffic flow.

In the 1990s, Romeoville began seeking new businesses and developers to expand the village and increase the tax base. As the village aged, the infrastructure needed improvement and replacement. New subdivisions appeared on the south and west sides of town, moving the population base away from the Hampton Park area. The population shift changed Weber Road from the western boundary into the center of the village and decreased local dependence on the businesses along Route 53.

Since 2010, redevelopment has started along Route 53, which had been Romeoville's entrance since the days of Routes 66 and 66A. With the help of federal funding, buildings have been remodeled and new businesses added. A recreation-sports-shopping complex replaced the Spartan Square shopping center.

Romeoville is a vibrant modern village of about 40,000 people who continue to care for their neighbors, as did the earliest residents of Romeo and Hampton Park. Churches collect for a year-round food pantry. Harvest Saturday, before Thanksgiving, and Operation Christmas annually help residents who are in need of assistance in preparing for the holidays. Special fundraisers support families in times of crisis. For example, they have helped a child with a concussion and a woman needing a ramp to accommodate her wheelchair.

The Romeoville Fire Academy, which trains firemen in emergency procedures, is noted throughout the state for its quality of training. Lewis University and Rasmussen College cooperate with the academy to provide college credit for their courses.

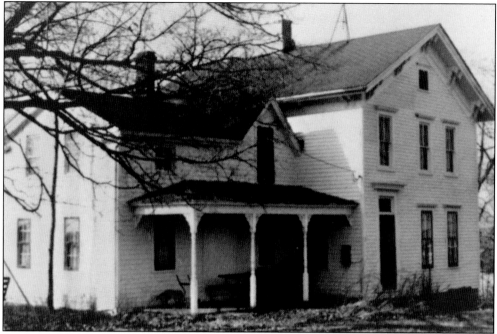

The Phelps-Spangler house was the home of Alice Spangler. The family sold off the farm land, retaining only the house and outbuildings. The house, at the corner of Route 53 and Normantown Road, was in the center of Romeoville in the 1980s when Alice died. Attempts to save the homestead failed, and the house was demolished.

The Save the Spangler House Committee and Romeoville Historical Society entered a replica of the Spangler house in the Founders Day parade in 1989 to spur interest in saving the historic home of Alice Phelps Spangler. A member of a well-known area family, Alice was the secretary for the DuPage Township one-room schools. The attendance records she maintained assist the historical society in locating farm families.

Dignitaries cut the ribbon to open the new Romeo Road Bridge on November 23, 1998. Pictured from left to right are John Strobbe, Lorraine "Sparky" Murphy, Mayor Frederick DeWald, village clerk Robert "Bob" Schneider, state representative Brent Hassert, and state senator Edward "Ed" Petka. The old bridge closed in 1990, cutting off "old Romeo" from the rest of the village. Protecting a rare emerald dragonfly and preserving the historic old bridge caused the delay in the new bridge's construction.

The Will County Forest Preserve bought land along the river and canal. The organization turned Murphy's Romeo Café into the park office and museum, as seen in 1996. The café bar was retained as the reception counter for the museum until the building was remodeled, as seen in the photograph.

Pres. Abraham Lincoln and Mary Todd Lincoln visited the Romeoville Historical Society in 1987. In the center, from left to right, are President Lincoln, state representative Brent Hassert, and Mary Todd Lincoln. Daniel Foran (left) and Greg Zibrun (right) are also pictured. Daniel and Greg are Romeoville men who participate in Civil War reenactments.

Volunteers built Safety Town in the 1990s from materials that were nearly all donated. It is believed that it was the first Safety Town built without the impetus of a child's death. The railroad car is the office and classroom. School classes and Scout troops learn safety here from volunteer coordinators. Halloween trick-or-treating at Safety Town was worry free, with village officials and staff distributing candy at the different buildings.

Old Chicago, which was located at the busy intersection of Interstate 55 and Route 53, was a landmark for both Romeoville and Bolingbrook. It housed an indoor amusement park and a high-end shopping center. It closed in the spring of 1980 and was torn down several years later. The area then became the Old Chicago Auto Auction.

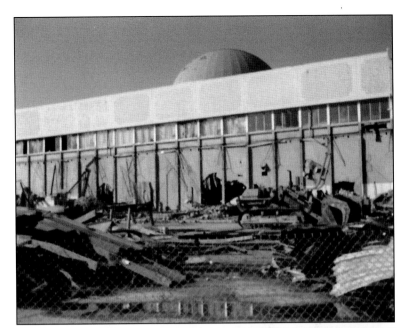

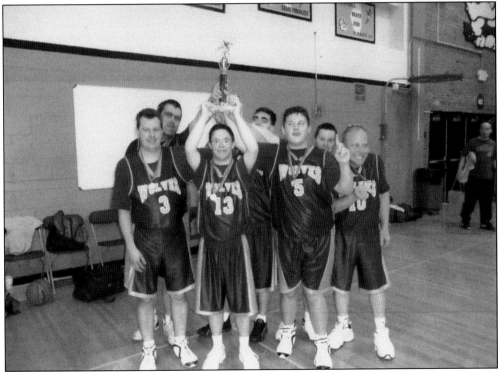

The Tri-County Special Recreation Association (SRA) provides recreational programs for people with disabilities and serves the families of Romeoville, Lemont Park District, and Lockport Township Park District. The SRA Wolves placed first at the 2012 Area 7 Special Olympics basketball tournament. Pictured from left to right are Scott Wells, Aleksandar Dragojlovic, Lyle Kane, Robert "Rob" Donofrio, Danny Wallace, James "Jim" Gottlick Jr., and Aaron Joseph. (Courtesy of SRA.)

St. Andrew parish started a November food drive for Romeoville's families in need. It grew into a partnership of churches with St. Andrew as the distribution center. The 19th Harvest Saturday was held in 2012. With more families needing assistance in the last 10 years, increased donations filled the demand. On the left is fire chief Kent Adams with trustee David Richards. Standing against the wall is trustee Brian Clancy. (Courtesy of Laura Katauskas of the *Bugle*.)

Wayne Littrell films one of the Romeoville Public Television (RPTV) telethon fundraisers held on Thanksgiving weekend to support the Operation Christmas program. Lois Anderson ran the program for many years. Although the telethons have stopped, Operation Christmas has provided gifts for less-fortunate Romeoville families for more than 35 years.

The fire department float in the 2011 Founders Day parade highlights its 50-year history. A department of volunteer firemen, followed by part-time officers, has become a vital force in the community. In 1995, voters approved a referendum to replace obsolete equipment. Pictured are, from left to right (first row) Phyllis Churulo, Albert "Al" Stadelmeier, and Carl Churulo; second row unidentified, Teresa "Terry" Ahern, unidentified, "Geri' Scharnagle, and Lynn Farr.

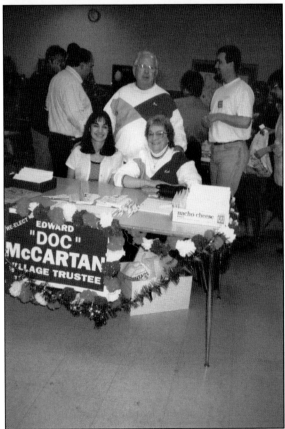

Edward "Doc" McCartan campaigned for office as village trustee in many elections and won each one. His self-imposed mission was to ask questions residents would like answered about new projects and policies. He stands in his campaign booth behind his granddaughter Lauren Ojeda, on the left, and wife, Ruth McCartan, sitting at the table. Doc's daughter Patricia "Patty" McCartan-Holloway followed her father into politics, becoming the DuPage Township collector.

Mayor John Noak speaks at the grand opening of the third village hall in 2010 during his first full term in office. With the staff and board of trustees, Noak oversaw the building project and completed plans for a new shopping and recreation center in the center of Hampton Park. Many new corporations moved into town, adding hundreds of jobs during a recession.

The village board of 2010–2013 poses in the boardroom of the third village hall. Pictured from left to right are Jose "Joe" Chavez, Kenneth "Ken" Griffin, Linda Palmiter, Mayor John Noak, village clerk Dr. Bernice Holloway, Brian Clancy, David "Dave" Richards, and Sue Miklevitz.

Waiting for the grand opening of the village hall complex are Police Chief Andrew "Andy" Barto, left, and Assistant Chief Mark Turvey, who was promoted to chief in April 2011 after Barto retired. The early Hampton Park policemen were part-time and had one squad car as well as one badge, which was left in the car for the next on-duty officer. Since the 1990s, each officer has his or her own a car and a badge. (JW.)

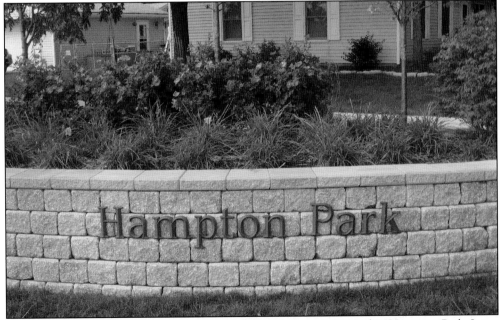

Off Route 53 and Belmont Avenue is a beautiful monument to remember Hampton Park. It is a miniature park with "Hampton Park" displayed on a natural stone wall. In 1957, six hundred acres of farmland on the west bank of the Des Plaines River became the Hampton Park community. The population soared from under 200 in 1950 to 3,574 in 1960.

The lobby of the new police station in the village hall complex reflects 50 years of dedicated service to the community. A flowing American flag and the mission statement of the police department are prominently displayed. State-of-the-art equipment instantly connects with the officers in their squad cars. (JW.)

The first Veterans Memorial was planned by Daniel "Dan" Sawin and built with donated materials by a team of volunteers. The plaques on the fence represent the five service branches and each war since World War I. The V shape stands for "veterans," according to Sawin. It was dedicated on Memorial Day 1990. Village representatives, local veterans, and historical associations placed wreaths there during Memorial Day and Veterans Day programs.

The Edward "Doc" McCartan Veterans Memorial is a sleek, modern park dedicated to Edward Doc McCartan, a veteran and longtime village board member. The black marble pillars symbolize each of the armed services. Paving tiles are inscribed to honor village veterans. The memorial opened on Veterans Day 2011, replacing the previous Veterans Memorial. Organizations continue the tradition of placing wreaths at the new memorial. (JW.)

In 2013, the Spartan Square shopping center, built in the 1950s, was razed. It was replaced by a civic center with a sports complex, stores, and an open-park area. The new complex provides services to residents of the east side of the village and is an attractive introduction to the village for visitors driving on Route 53.

DISCOVER THOUSANDS OF LOCAL HISTORY BOOKS FEATURING MILLIONS OF VINTAGE IMAGES

Arcadia Publishing, the leading local history publisher in the United States, is committed to making history accessible and meaningful through publishing books that celebrate and preserve the heritage of America's people and places.

Find more books like this at
www.arcadiapublishing.com

Search for your hometown history, your old stomping grounds, and even your favorite sports team.